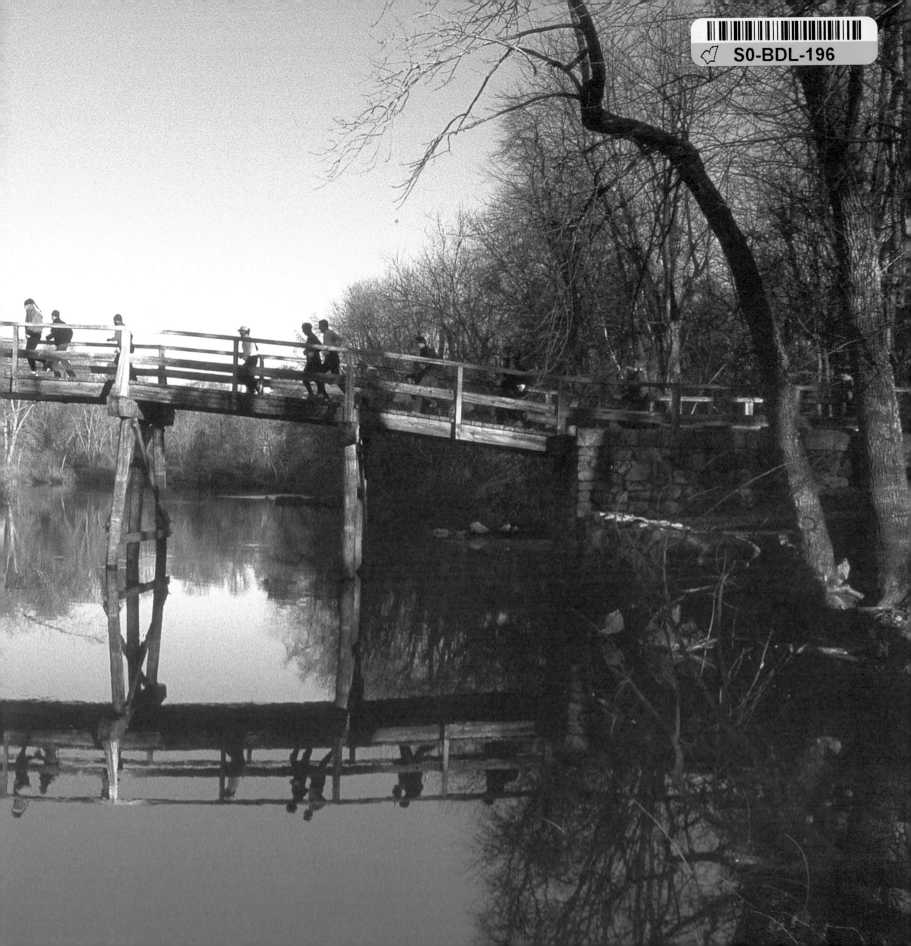

Concord

ISBN 1-889833-39-8

Cover and interior design by Jill A. Feron/Feron Design.
Printed in Korea.

Published by Commonwealth Editions,
an imprint of Memoirs Unlimited, Inc.,
266 Cabot Street, Beverly, Massachusetts 01915.

Visit our Web site: www.commonwealtheditions.com.

Concord

MASSACHUSETTS

Photographs by John Kennard

COMMONWEALTH EDITIONS
Beverly, Massachusetts

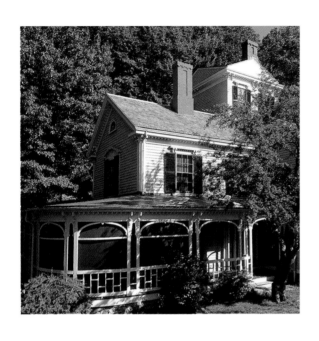
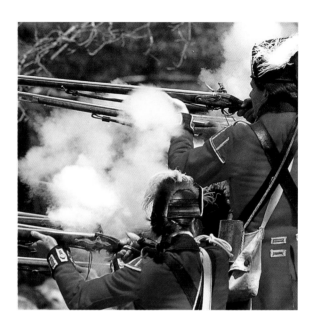
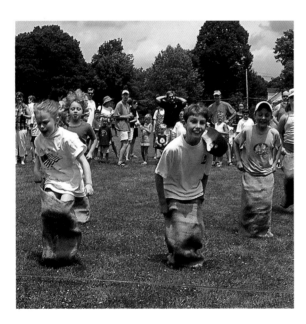
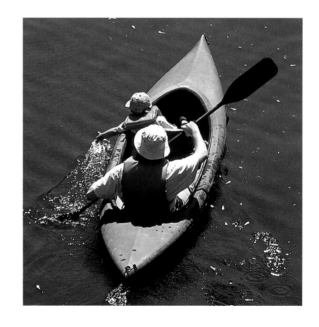

Foreword

By sheer coincidence, immediately after seeing John Kennard's pictures for the first time, I was invited to look at a collection of old Concord photographs and postcards made in the early 1900s, when Monument Square was crisscrossed with pathways, and the Whipping Tree still stood gloriously in front of the Town House. They were quietly elegant images resplendent with silence and serenity. Even a horse at the Common watering trough seemed habitually incapable of anything as urgent as thirst.

Later, since it was a lovely day, I walked along the Milldam, looked anxiously for careless drivers before hastening across the street, watched a cacophonous flock of blackbirds in the trees in front of the bank, and exchanged smiles with a happy mother who was wheeling her beautiful son and daughter along the sidewalk—each one licking an ice cream cone as if there were nothing better in the world to do on a sunny afternoon than eat pink ice cream. It was as if I had stepped into one of the images in this book.

Passing the shops, with their quaint signs and tastefully decorated windows, I thought about how enthusiastically we Concordians commemorate our collective memories. We know how to celebrate. We take great pleasure and pride in it. Certainly, there have been snowy, sunny, warm, wet April nineteenths; snowy, starry, warm, wet Christmas Eves; and blazing hot July Fourths with thunder grumbling in the western hills—yet none of that matters because everyone enjoys being together to share the festive event. And when it's time for business? The civic-minded men and women—their faces familiar, their dedication unshakable—share the responsibilities of town management. A year or so ago I had a conversation with the town manager about the number of town committees. We agreed that community participation in town affairs has always been a defining feature of Concord's political profile. He said that such informed, competent, willing participants are sometimes difficult to find in other Massachusetts communities. Yes, I thought, Concord's historic legacy is about doing. About being responsible.

My walk through town took me past the graveyards, those hallowed grounds designed for respectful contemplation. I looked at the old slate and granite headstones, which historian Alfred Hudson called the "faithful waymarks of history [which] still chronicle by their suggestiveness what has made the old town great." With Kennard's pictures freshly in mind, I realized that I have never visited the prison cemetery at MCI-Concord, where more than two hundred men have been buried,

the first in 1878. It is one of the least-discussed parts of town, so obvious from above, so massive, so forgettable. Some people in town still remember the Reformatory, as it was called when it was a quality vocational institution and an important local source of employment. Nowadays, I suspect that most Concordians think about MCI-Concord with tolerant neutrality.

Pausing to look down at the water as I crossed the bridge, I realized how impossible it is to live in Concord without being a contributor of some sort in the town's determination to protect its rivers and its open space. It isn't just about the river mist on winter mornings, or the autumn views from Fairhaven Hill when the bronze oaks glow in the hazy sunshine, it is about conservation—and as Concordians we actively uphold the dictum of forceful accountability for maintaining the integrity of our natural resources. We were brought up on Henry David Thoreau's essays describing the splendors of Walden Pond, the Concord River, and the Estabrook Woods, and on Ralph Waldo Emerson's devoted hometown tribute, "Here once the embattled farmers stood / And fired the shot heard round the world." We never forget what these two men did for our town.

Home was just a few steps farther on. I asked myself what it is really like to live in Concord with our present perspective so vividly colored by the remnants of the past. There is an answer. Look for it in John Kennard's images.

Sarah Chapin
Spring 2002

Acknowledgments

A town is a complex being. Revered for its place in American history and for the literature and ideas spawned here; home to MCI-Concord and Middlesex School, to a Superfund site and to Walden Pond; flush with daytrippers and families who have been here for generations—Concord is no exception. Out of the fragments we call photographs I have tried to piece together a picture of this being called Concord.

I thank all those who grace the pages of this book, wittingly and unwittingly. For all the ideas from friends and strangers, thank you. Thanks to Anne Umphrey of Concord Copters for some great views; to State Representative Cory Atkins and to Justin Latini of the Department of Corrections for getting me into jail; to Kathy Wright, the fox, and the crew of the Old North Bridge Hounds for teaching me the joys of sherry on a brisk autumn morning; to Rebecca Purcell for being a constant source of information; to Jan Turnquist, Laurie Butters, Bob Derry, Bob Hall, Lisa Rookard, Tara Bradley, Dorothy Schechter, Tom Blanding, and Laurel Landry. A special note of thanks to Dale Szczeblowski at the Concord Bookshop for making the connection that led to this book. My thanks to Sally Chapin for her "stroll through town." And a final thanks to Webster, Liz, and Jill, and to all the staff at Commonwealth Editions for being supportive throughout the process of putting this book together.

Concord is renowned for many reasons. For me, however, its greatest significance is that I have lived a quarter of my life here and have raised my sons here. I dedicate this work to the best in my life, Philip and Henry, and, oh yes, to Toby, for keeping me sane. Arf!

John Kennard
May 2002

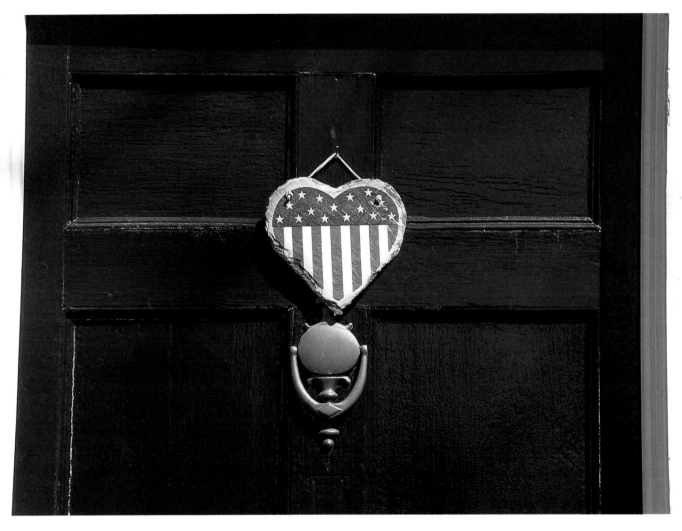

Door, Monument Square

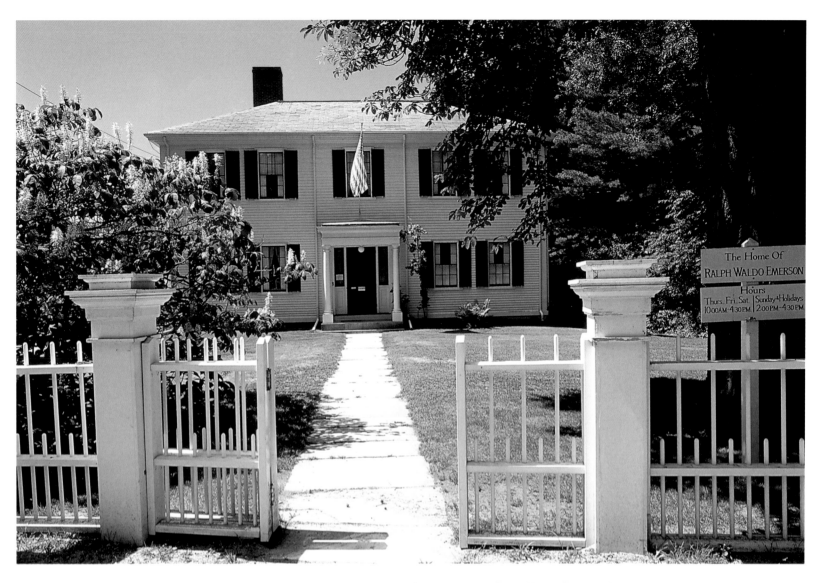

Ralph Waldo Emerson's home, which the family called "Bush." Owned by the Ralph Waldo Emerson Memorial Association,
which includes members of the Emerson family, it was Emerson's home from 1835 until his death in 1882.

*Would you know what joy is hid
In our green Musketaquid,
And for travelled eyes what charms
Draw us to these meadow farms,
Come and I will show you all
Make each day a festival.*

—Ralph Waldo Emerson,
"Sunrise"

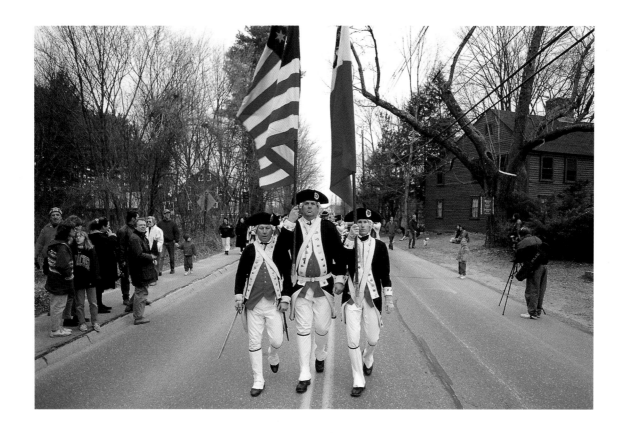

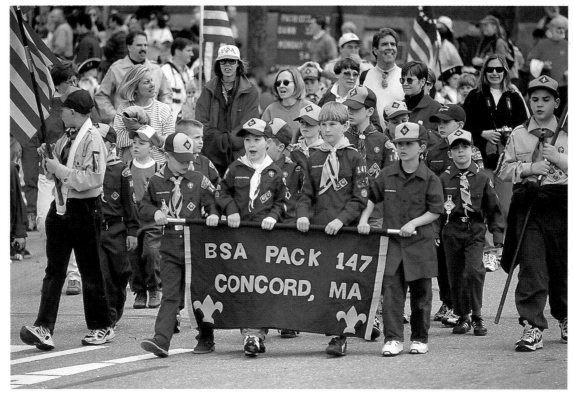

(Top)
The Meriam's
Corner exercise
commemorates
the events of
April 19, 1775.

(Bottom)
Patriots Day parade

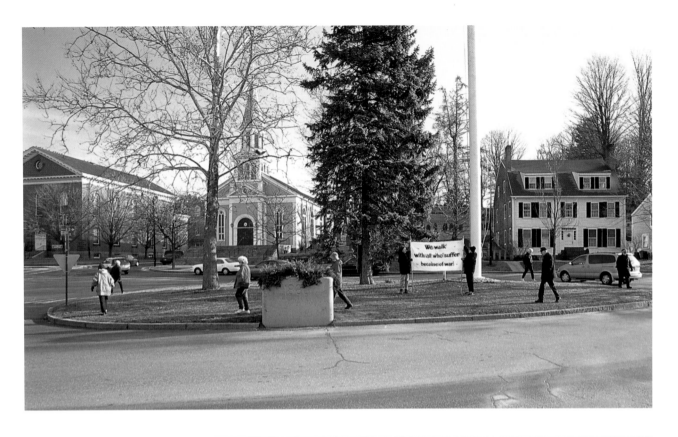

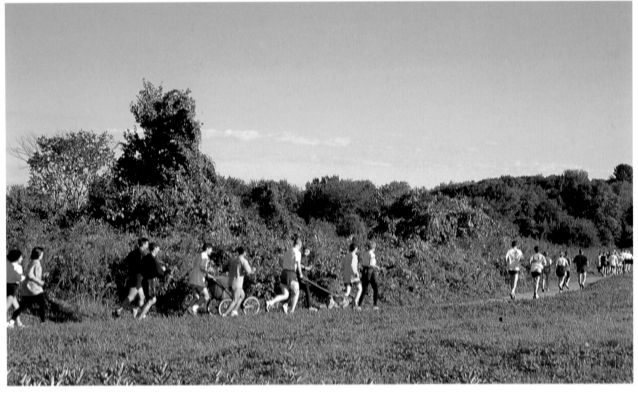

(Top)
Citizens walk
in silence during
the Friday Peace
Vigil held in
Monument Square.

(Bottom)
Concord Runners,
Minuteman
National Historic
Park. The informal
running group of
over one hundred
has been active
since 1978.

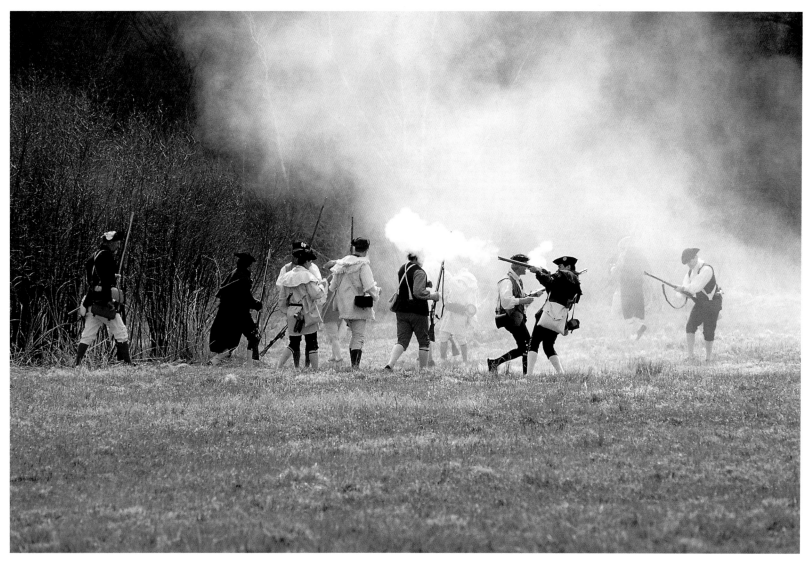

Meriam's Corner re-enactment, at the site of the April 19 skirmish between retreating British Redcoats and provincial Minutemen and militia

In re-enacting historical events, I seek to bring the past to the present by transporting the viewer to another place and time in an understandable context. I assume a period persona, portraying an actual individual, who once lived the moments I recreate. The re-enactments evoke emotions, but their primary goal is to provoke thought while expressing and defining the truth of a moment in our history.

—D. Michael Ryan, historian and re-enactor

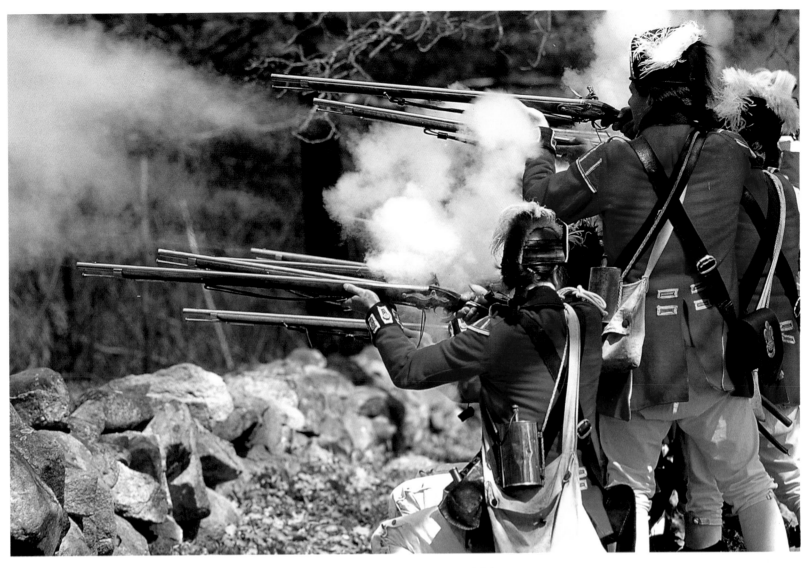

Commemoration of the Concord fight

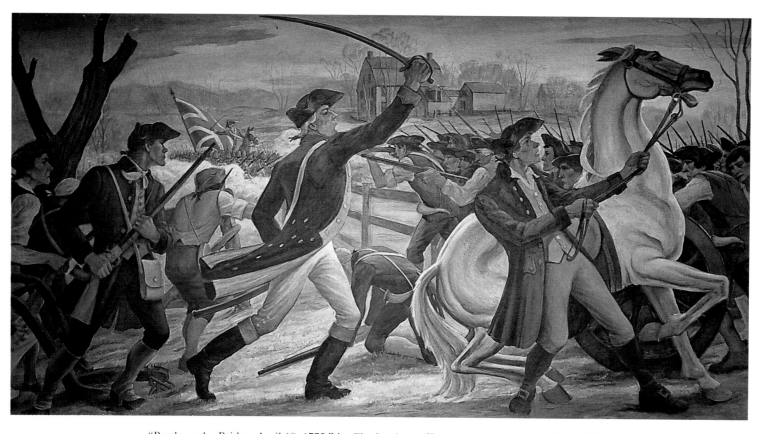

"Battle at the Bridge, April 19, 1775," by Charles Anton Kaeselau, at the Concord Post Office

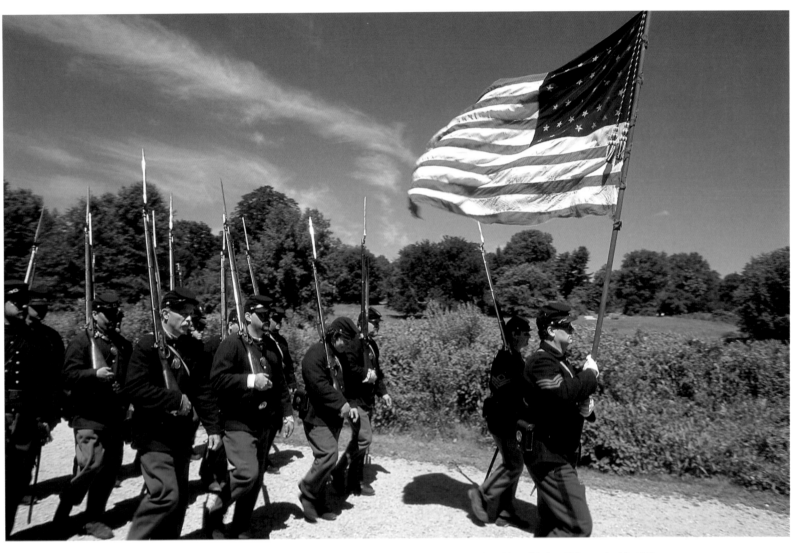

Civil War encampment, held at the Old Manse every July. It celebrates the time Ezra Ripley II brought his B Company
to Concord before they headed to war, so they could see where their ancestors had fought for their beliefs.

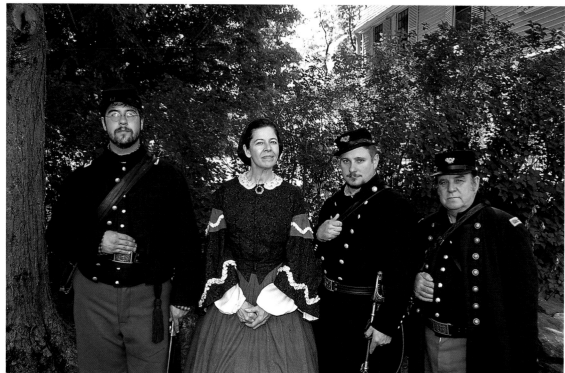

(Top)
Civil War encampment,
Old Manse

(Bottom)
Civil War re-enactment
at the Old Manse, with
Ezra Ripley II, Louisa May
Alcott, and two members
of the 28th Regulars of
Massachusetts Volunteers

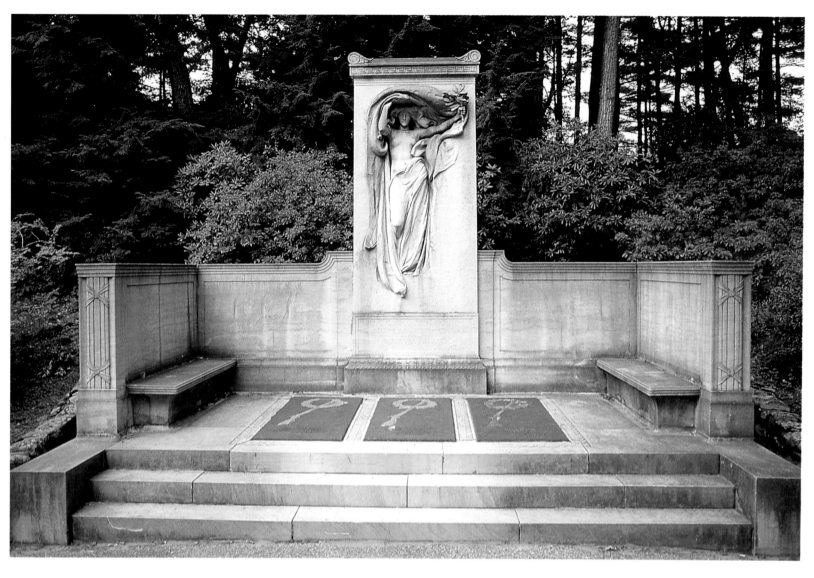

The Melvin Memorial, created by Daniel Chester French and dedicated June 1909:
"In memory of three brothers in Concord who as private soldiers gave their lives in the war to save the country.
This memorial is placed here by their surviving brother, himself a private soldier in the same war."

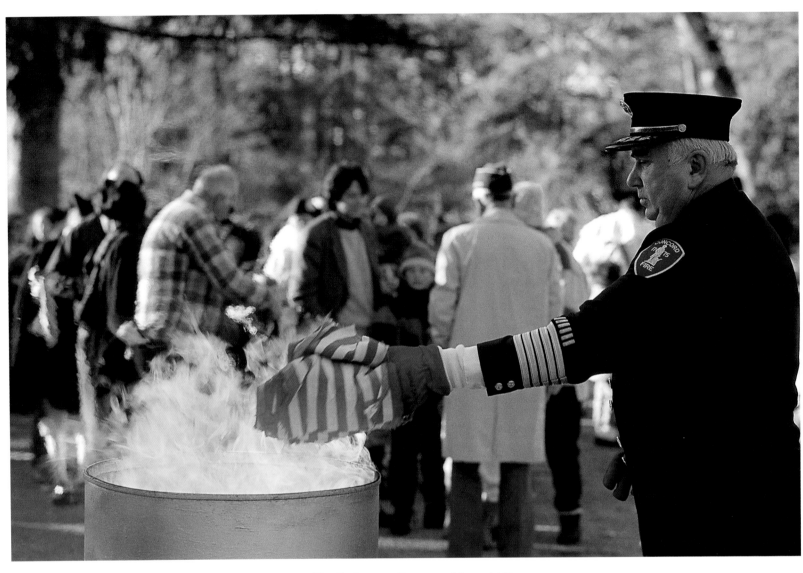

Flag Retirement Ceremony, Memorial Day

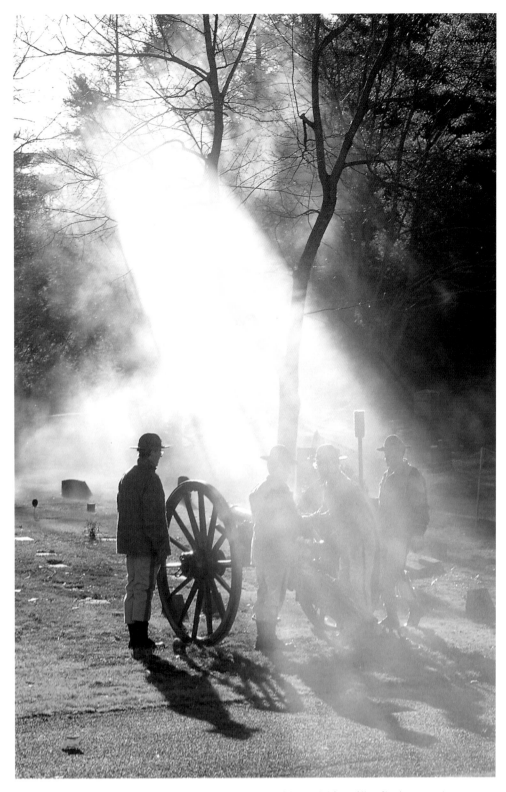

Cannon salute by the Concord Independent Battery, Memorial Day Flag Retirement Ceremony

You really think that nothing can be said about morning and evening, and the fact is, morning and evening have not yet begun to be described.

—Ralph Waldo Emerson

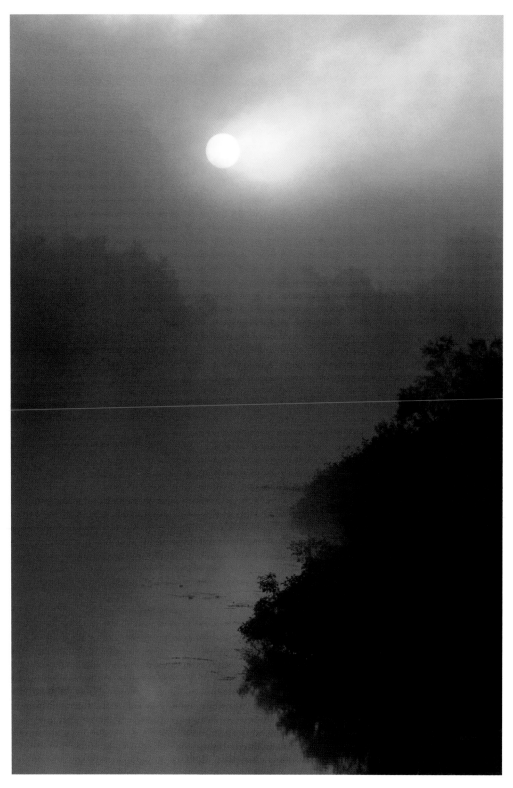

Sunrise on the Sudbury River

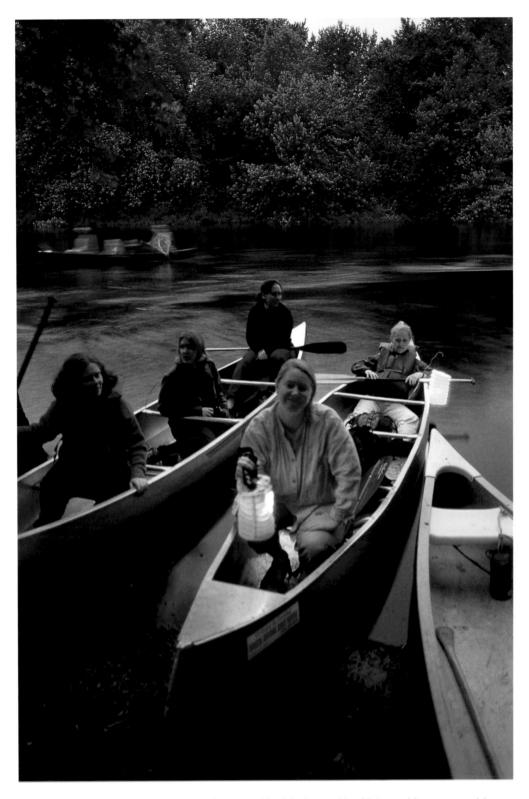

The River Solstice Lantern Parade is planned by Musketaquid, which provides opportunities
to create and experience art while exploring and learning about the local environment.

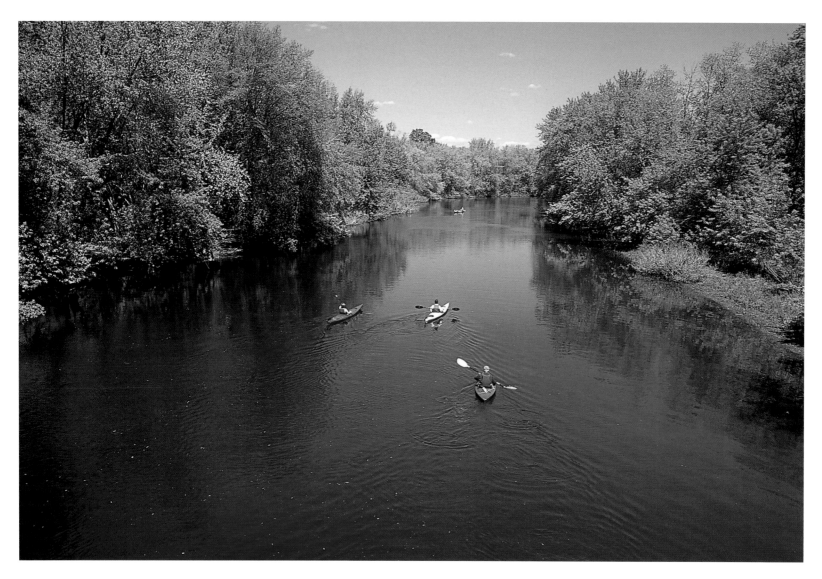

Concord River

*It may well be called the Concord,
the river of peace and quietness;
for it is certainly the most unexcitable
and sluggish stream that ever loitered
imperceptibly towards its eternity—
the sea.*

—Nathaniel Hawthorne

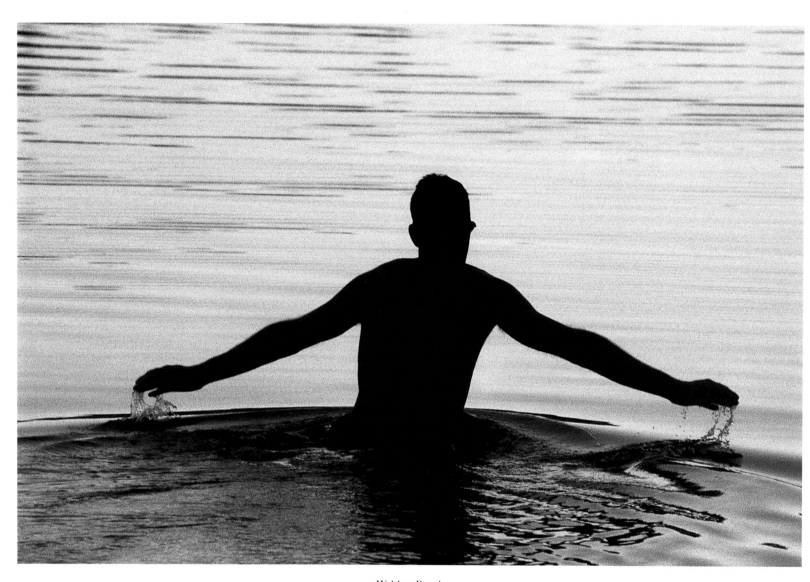

Walden Pond

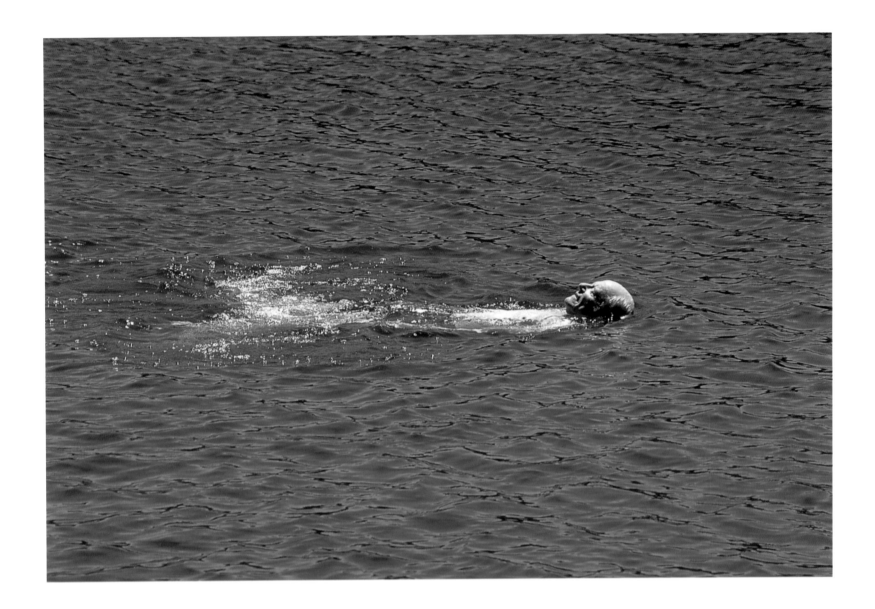

My townsmen have all heard the tradition . . . that anciently the Indians were holding a pow-wow upon a hill here, which rose as high into the heavens as the pond now sinks deep into the earth, and they used much profanity, as the story goes, though this vice is one of which the Indians were never guilty, and while they were thus engaged the hill shook and suddenly sank, and only one old squaw, named Walden, escaped, and from her the pond was named. It has been conjectured that when the hill shook these stones rolled down its side and became the present shore.

—Henry David Thoreau

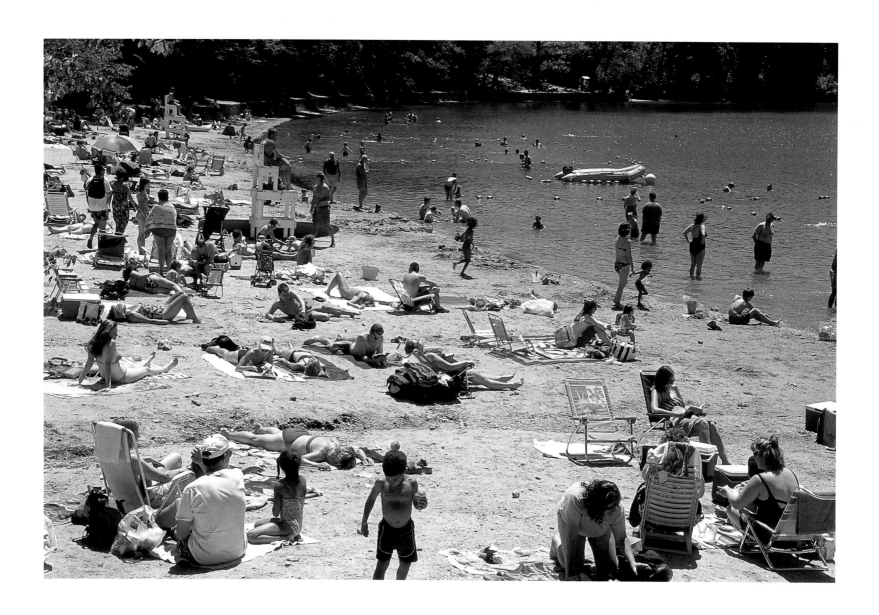

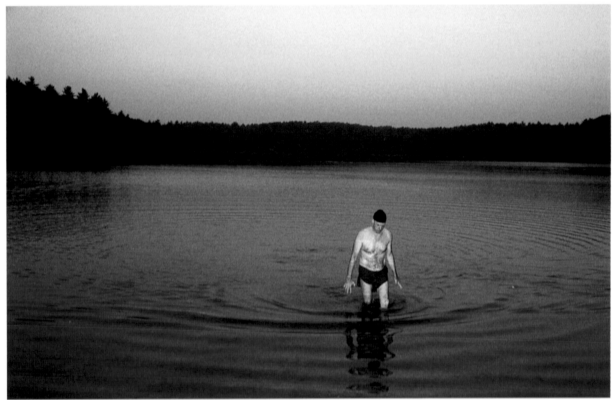

(Opposite and top)
Walden Pond

(Bottom)
Early morning
swimmer

27

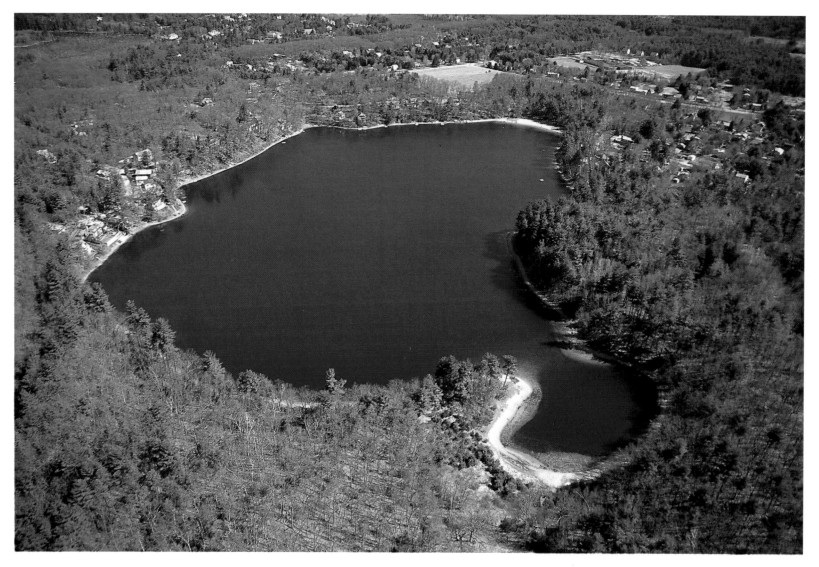

White Pond

A lake is the landscape's most beautiful and expressive feature. It is earth's eye, looking into which the beholder measures the depth of his own nature.

—Henry David Thoreau

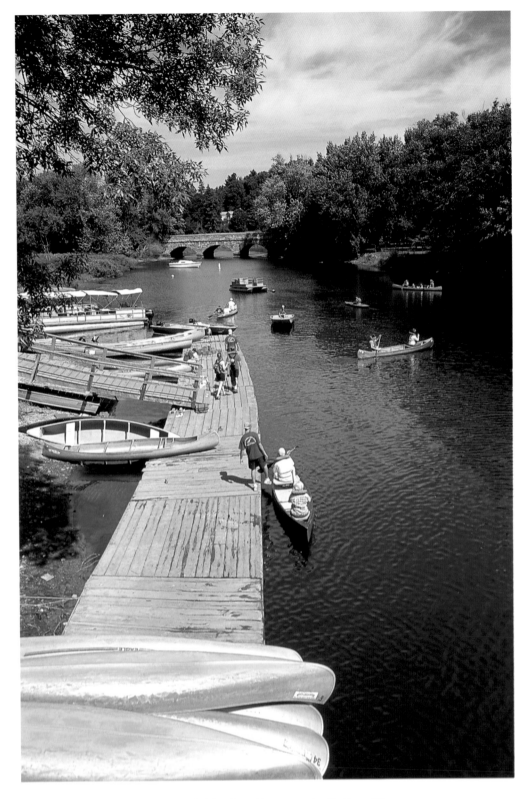

The South Bridge Boat House, on the Sudbury River,
has been renting and selling boats and canoes for over a century.

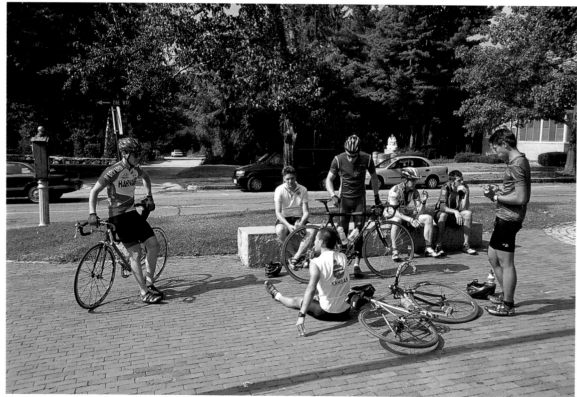

(Top)
Concord Runners
crossing Route 2.

(Bottom)
Monument Square

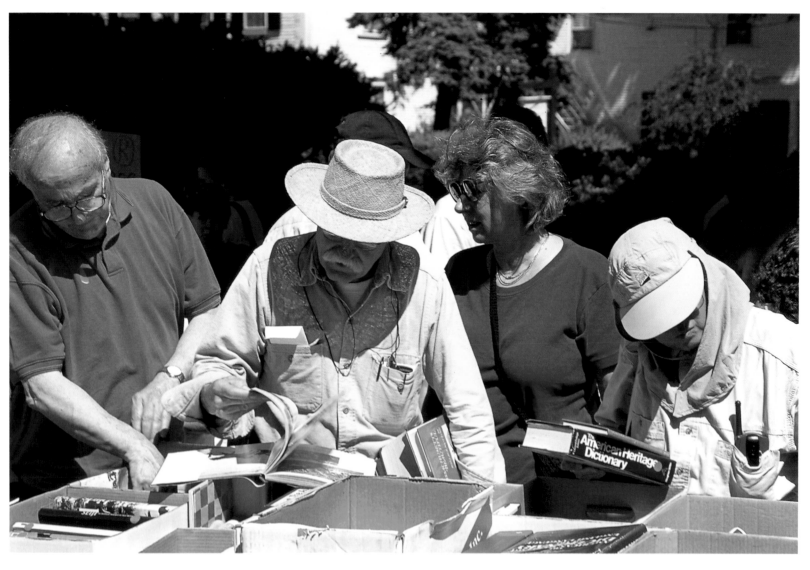

Book sale, Concord Free Public Library

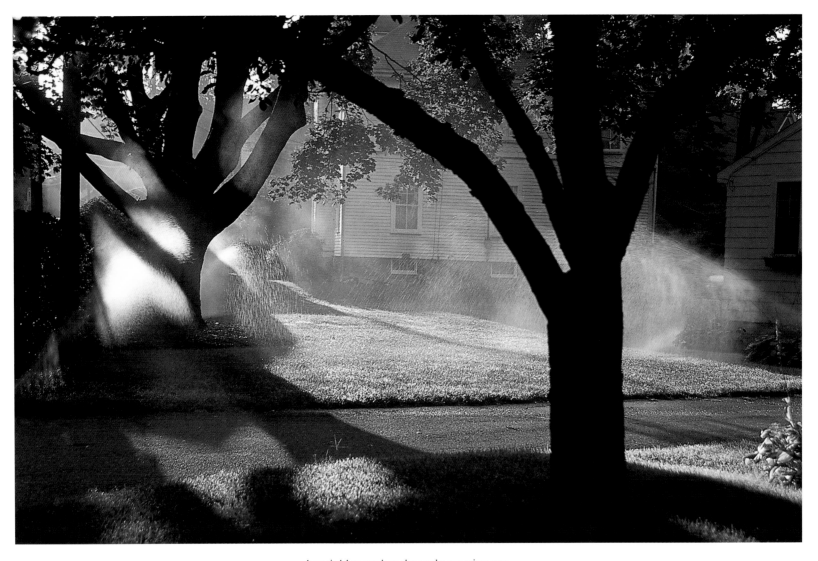

A sprinkler catches the early morning sun.

I am cheered with the moist, warm,
glittering, budding and melodious hour
that takes down the narrow walls of my
soul and extends its pulsation and life to
the very horizon.

 —Ralph Waldo Emerson

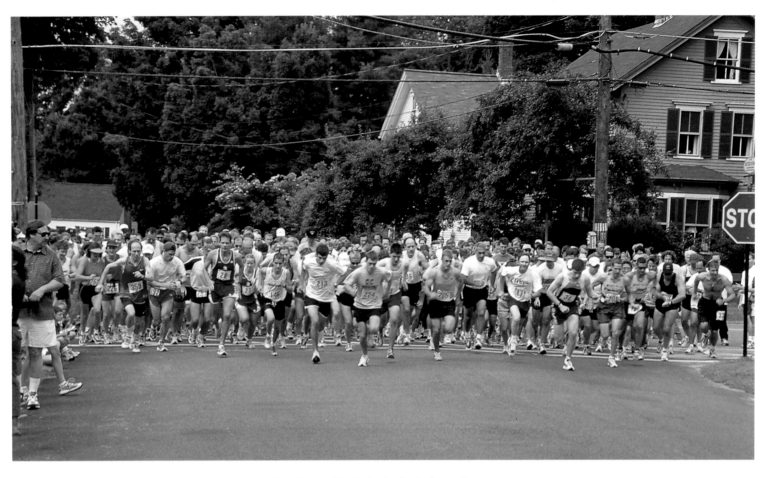

July Fourth Picnic in the Park, five-mile race

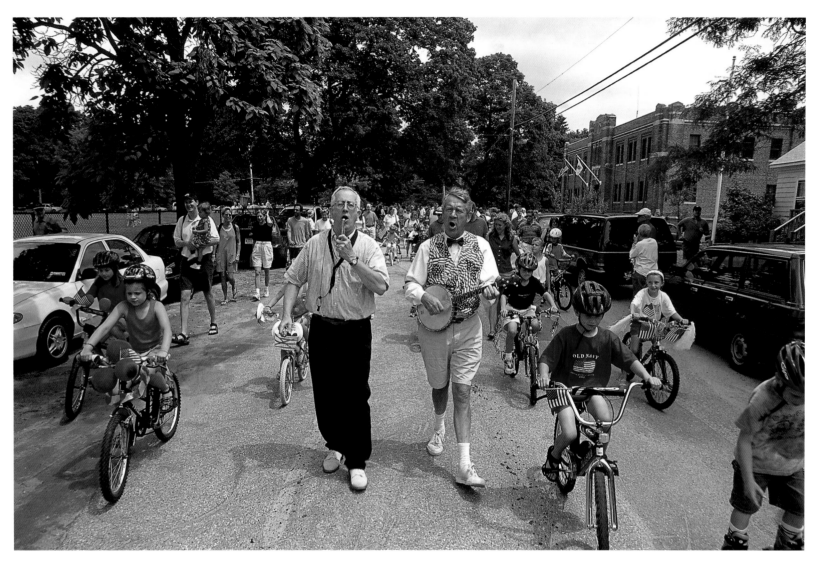

July Fourth Picnic in the Park

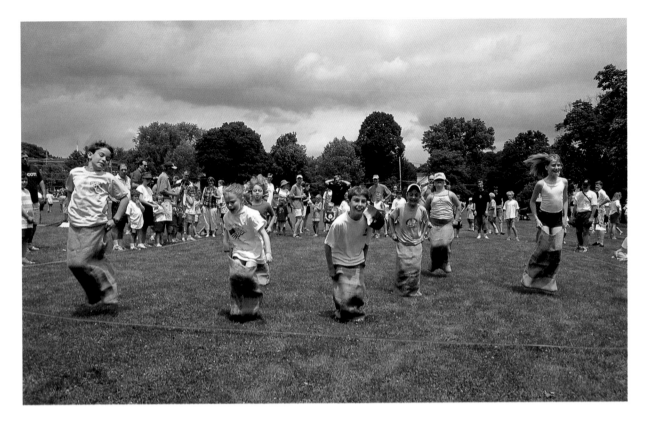

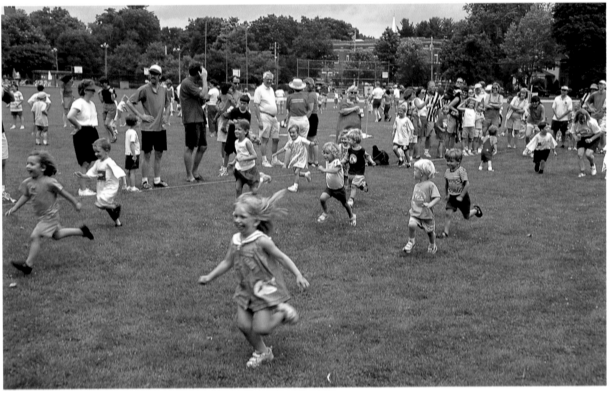

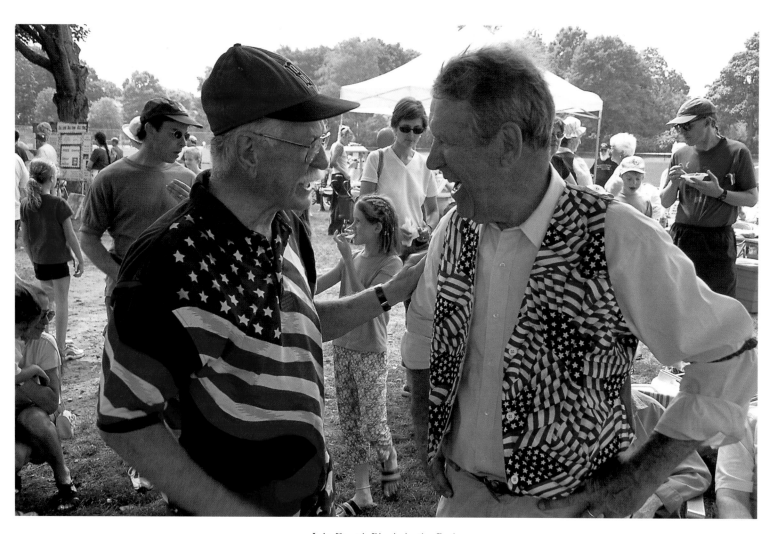

July Fourth Picnic in the Park

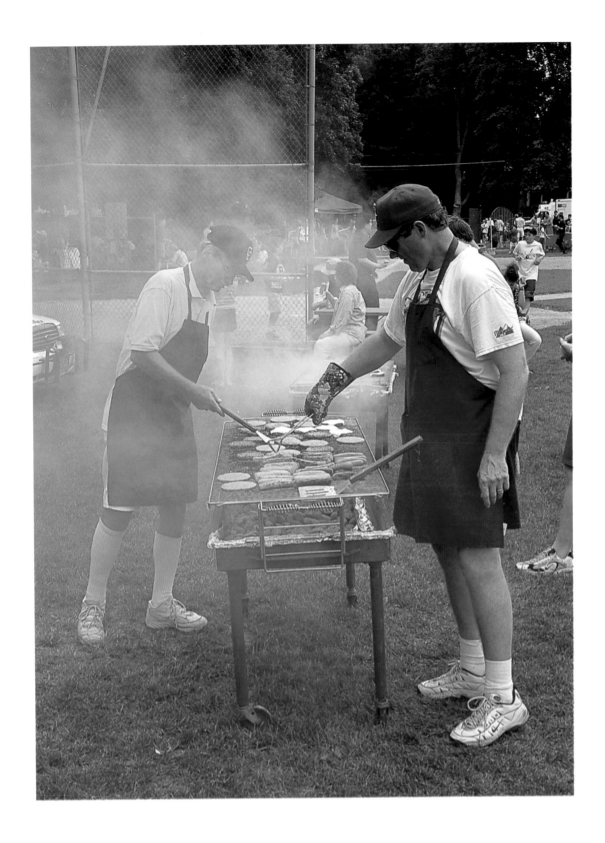

Main Street

Emerson Field

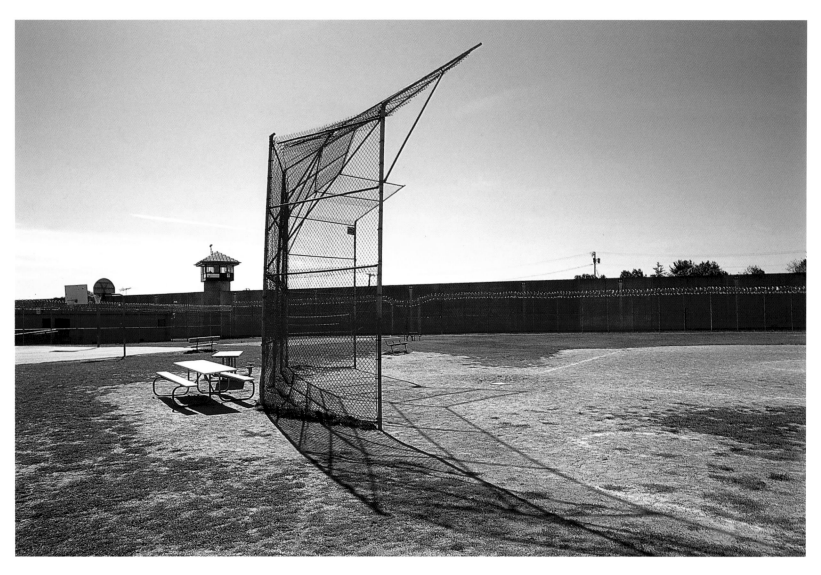

Baseball diamond, MCI-Concord

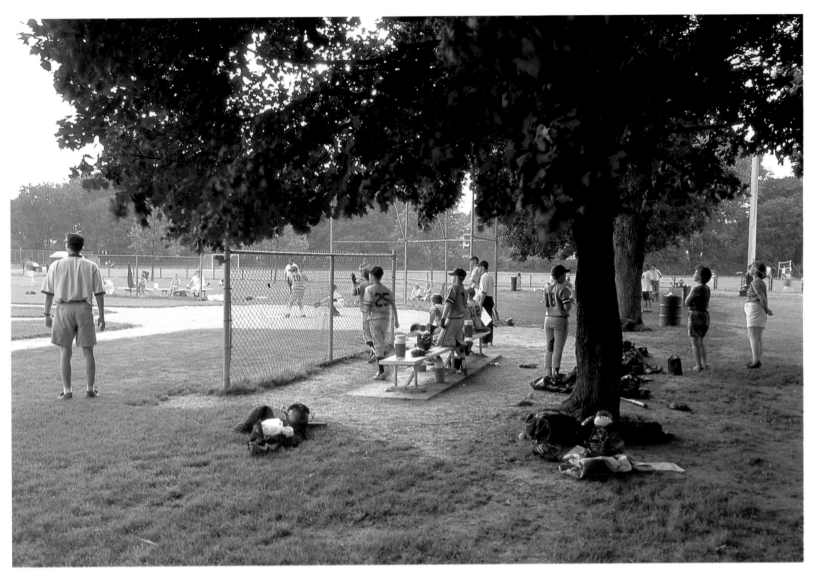

Emerson Field

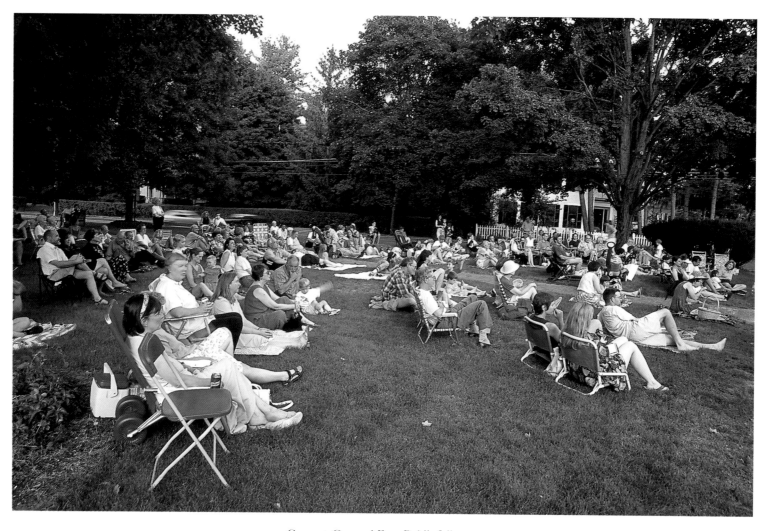

Concert, Concord Free Public Library

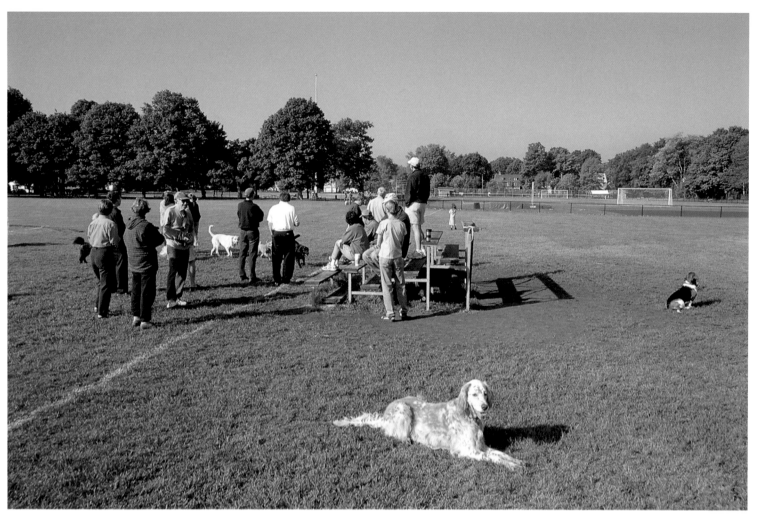

The Dog Walkers Group meets every Saturday at Emerson Field.

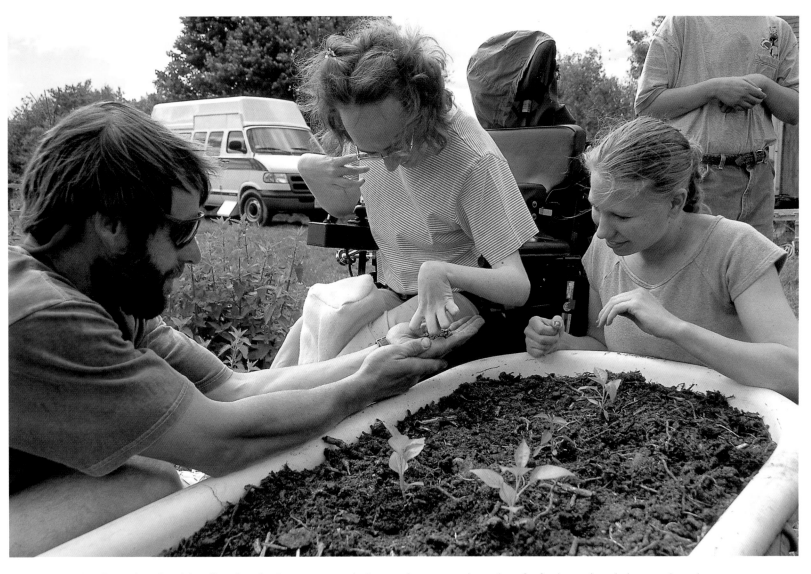

Gaining Ground works with a diversity of volunteers to teach about and grow organic produce for food pantries, shelters, and meal programs. (*Left to right:* Mark Waltermire, Lisa Roy, and Daisy Merritt)

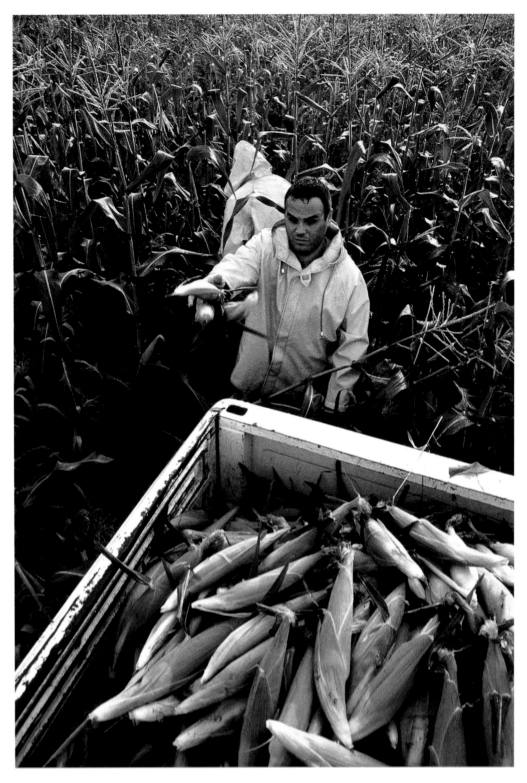

Corn picking at Pine Tree Farm

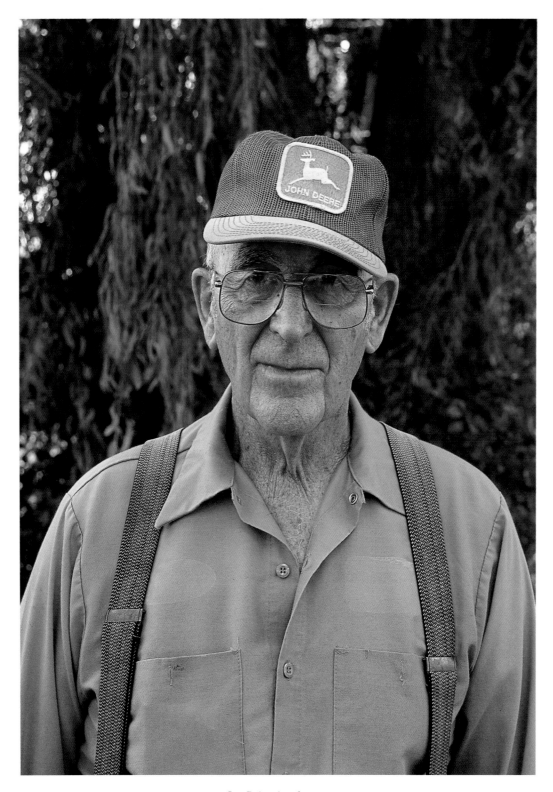

Joe Palumbo, farmer

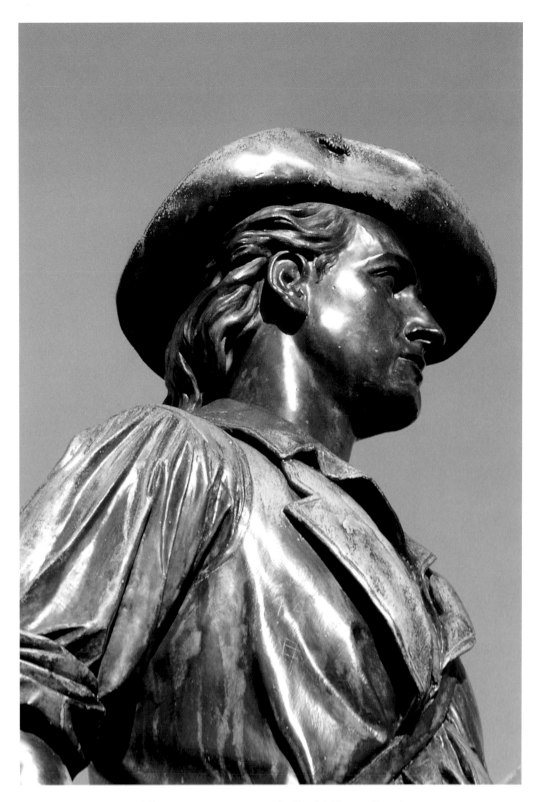

Minuteman statue, created by Daniel Chester French
and dedicated at the centennial celebrations in 1875

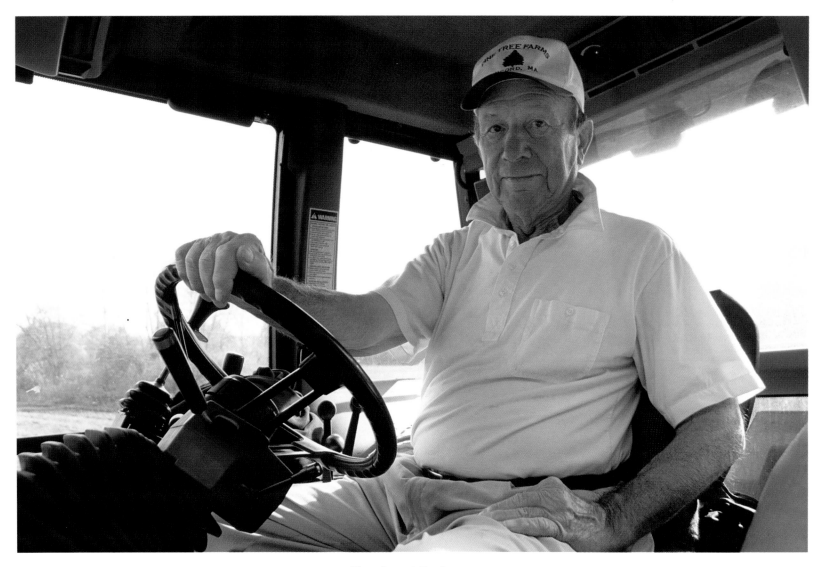

Tony Amendolia, farmer

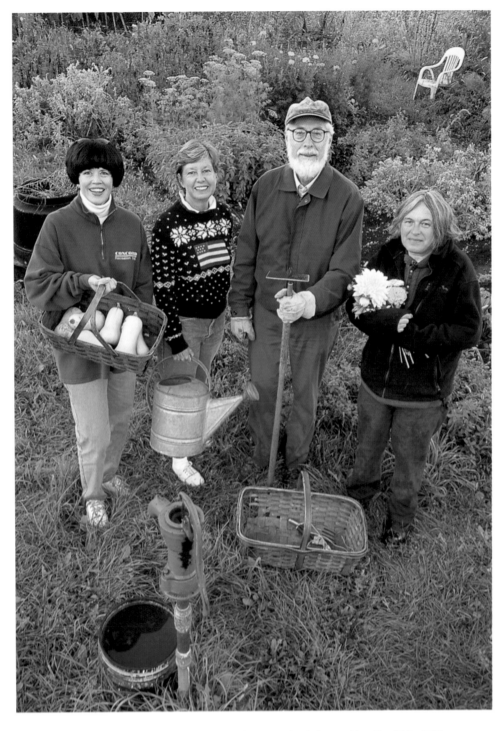

The Hugh Cargill Community Gardens—on land donated by Cargill in 1799
"for the benefit of the poor"—carry on Concord's agrarian tradition
and provide a gardening community for all residents.
(*Left to right:* Rebecca Purcell, Nancy James, Ivan Kaufman, and Erica Nesja)

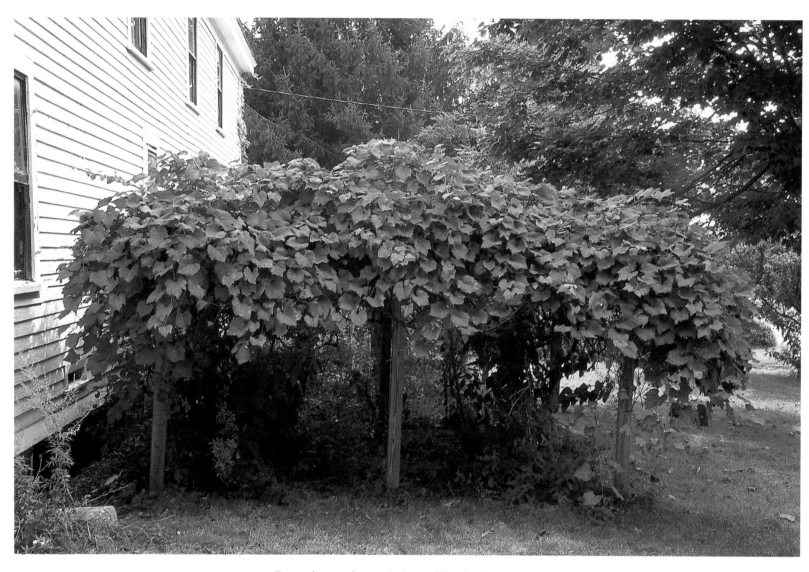

Concord grapevines at Anderson Wheeler Homestead

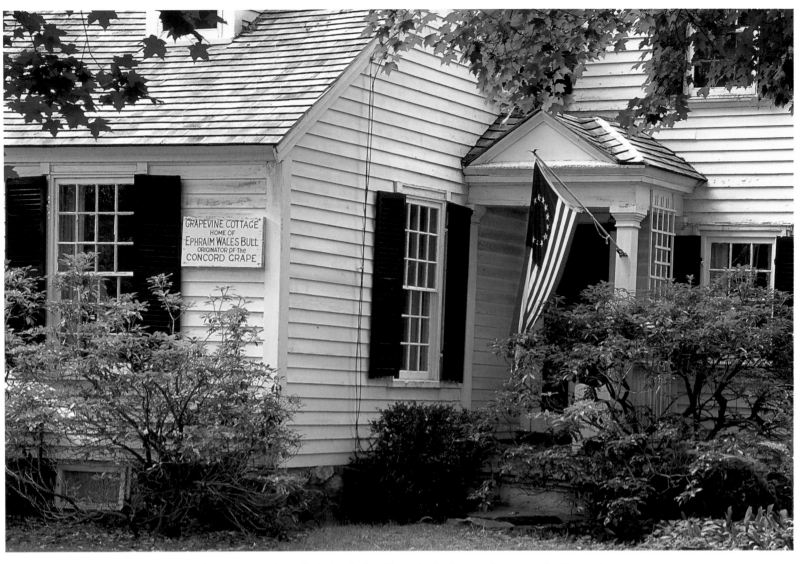

Grapevine Cottage, where Ephraim Bull cultivated what became known as the Concord grape

The sign on the house reads:

GRAPEVINE COTTAGE
HOME OF
EPHRAIM WALES BULL
ORIGINATOR OF THE
CONCORD GRAPE

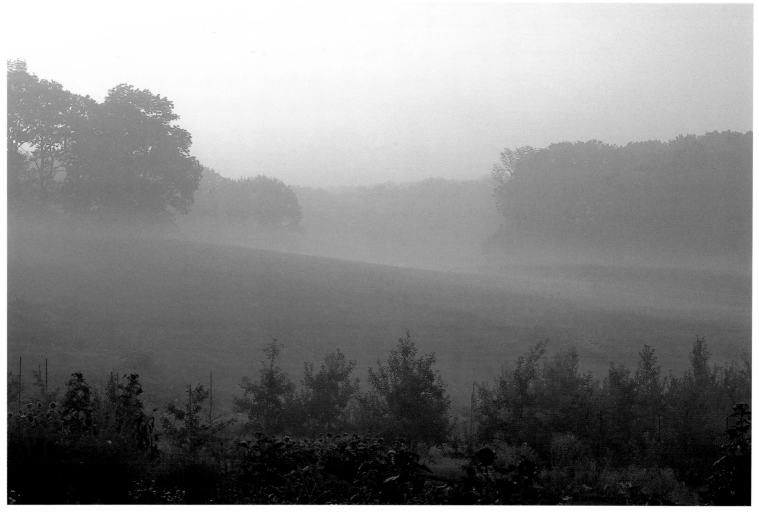

Sunrise at Hutchins Farm

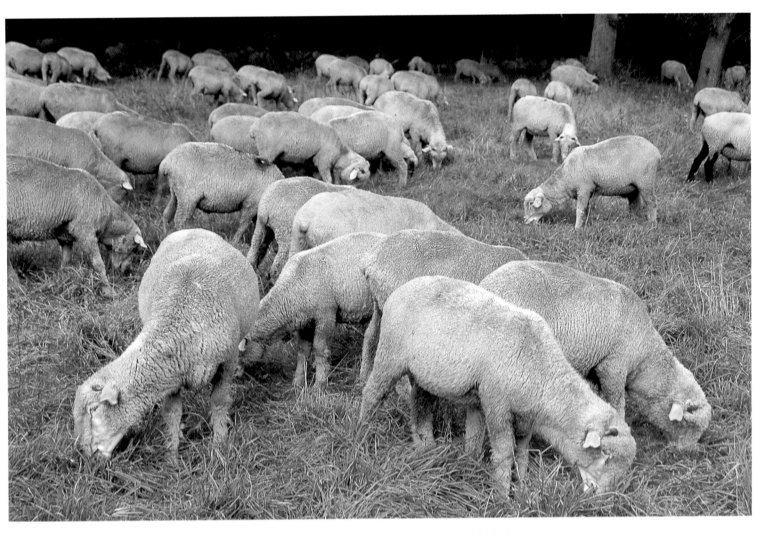

Grazing sheep, Minute Man National Historical Park

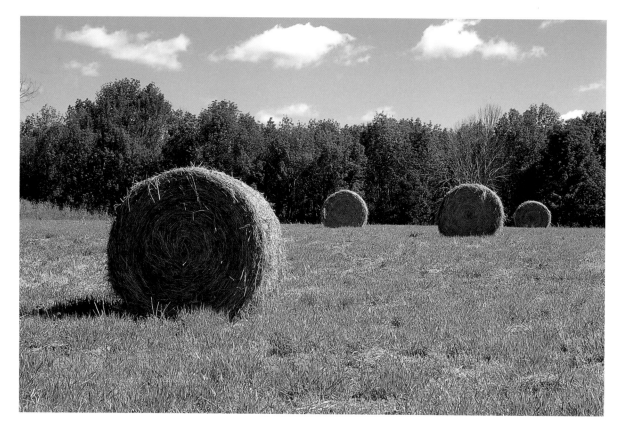

(Top)
Hay bales

(Bottom)
Pine Tree Farm

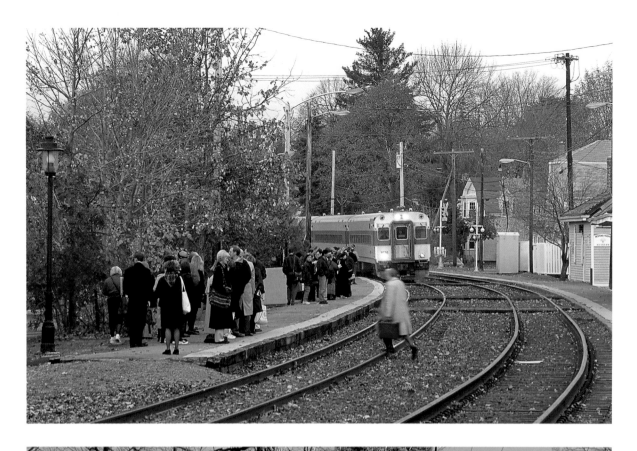

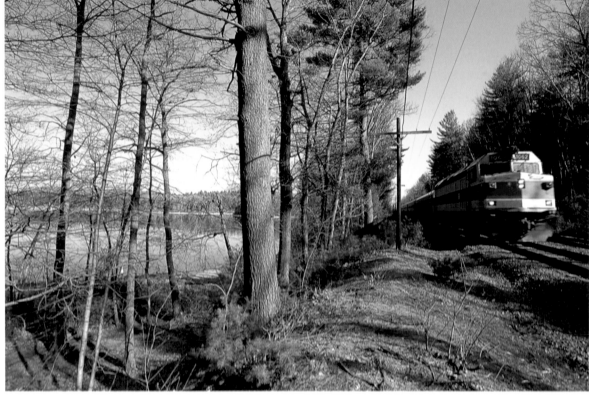

(Top)
Concord train depot

(Bottom)
The Fitchburg Line,
running past Walden
Pond as it has since
1844

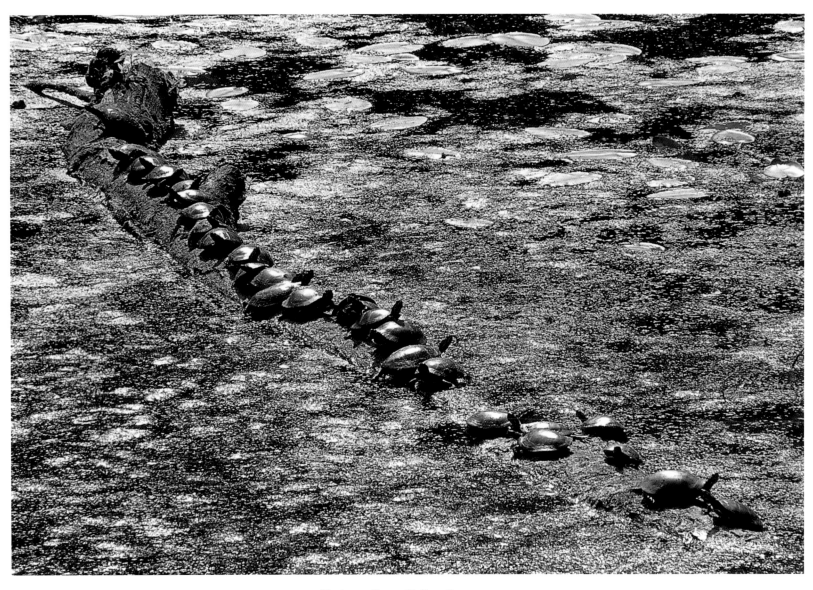

Turtles at Sleepy Hollow Cemetery

Walden Pond

Purple loosestrife

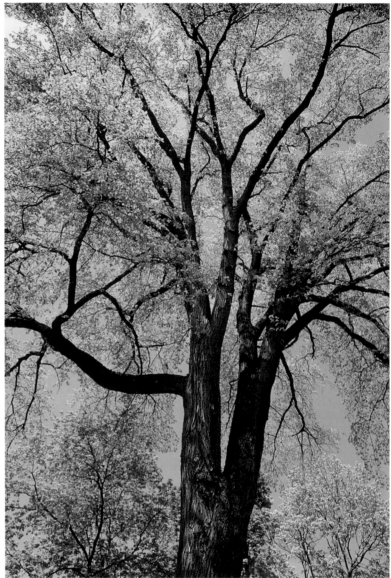

Elm tree, Lexington Road

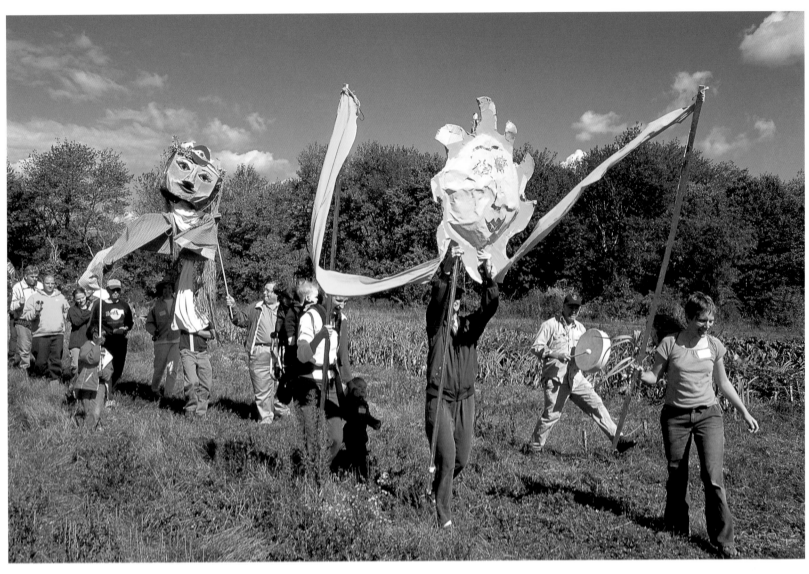

Musketaquid Gaining Ground Harvest Fest

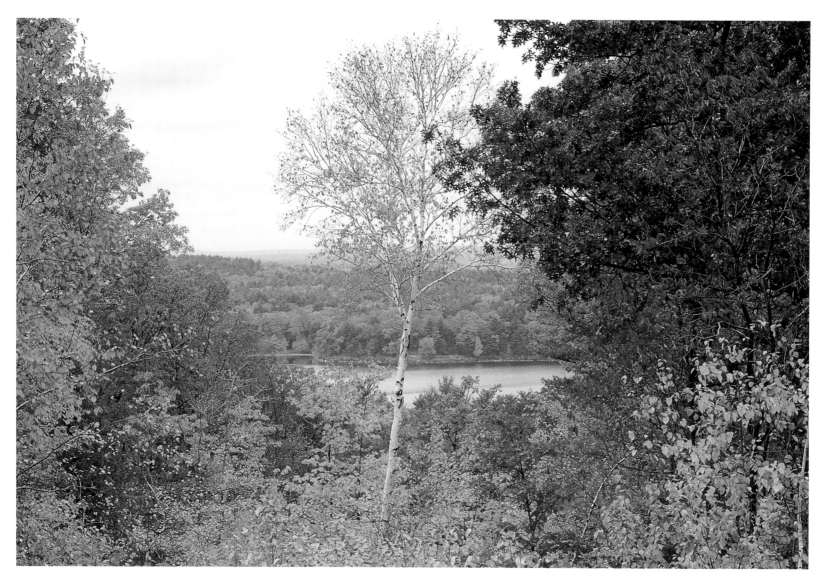

Walden Pond from Pine Hill

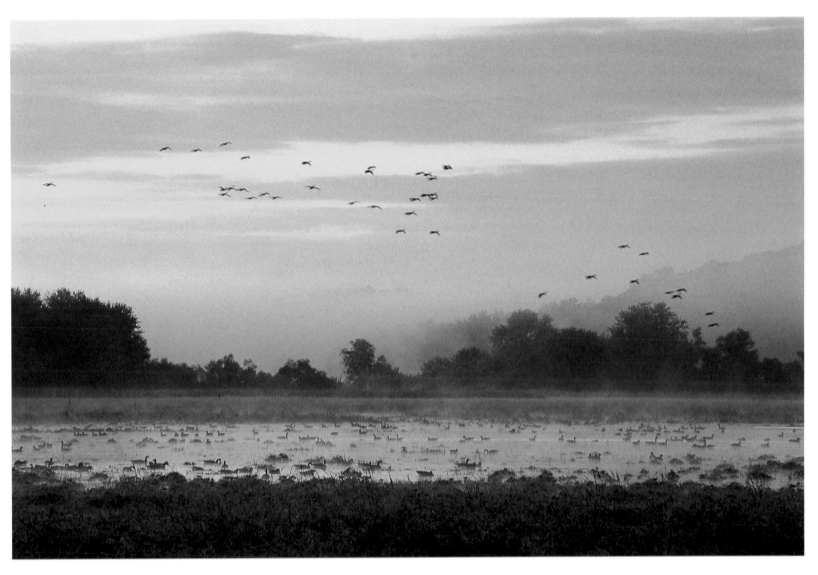

Sundown at Great Meadows National Wildlife Refuge. The refuge was created in 1944, when Samuel Hoar donated 250 acres to be held in perpetuity as a wildlife sanctuary.

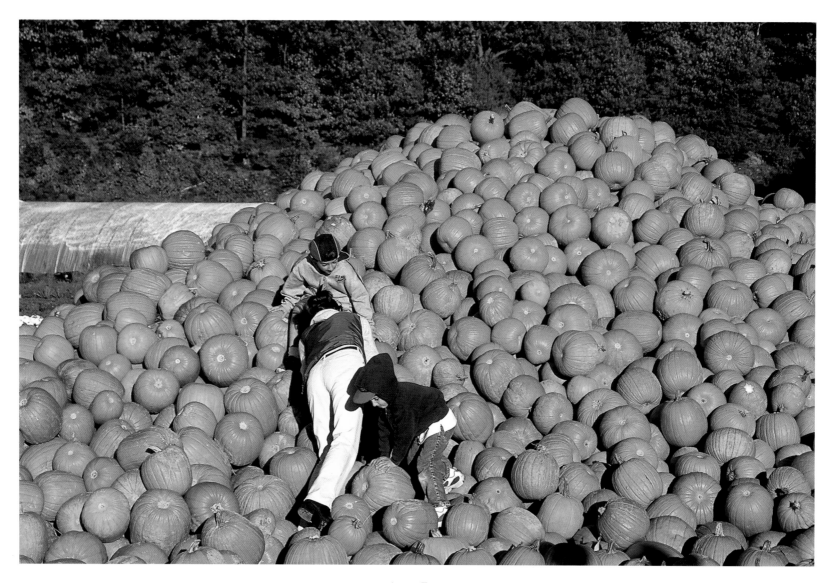

Arena Farm

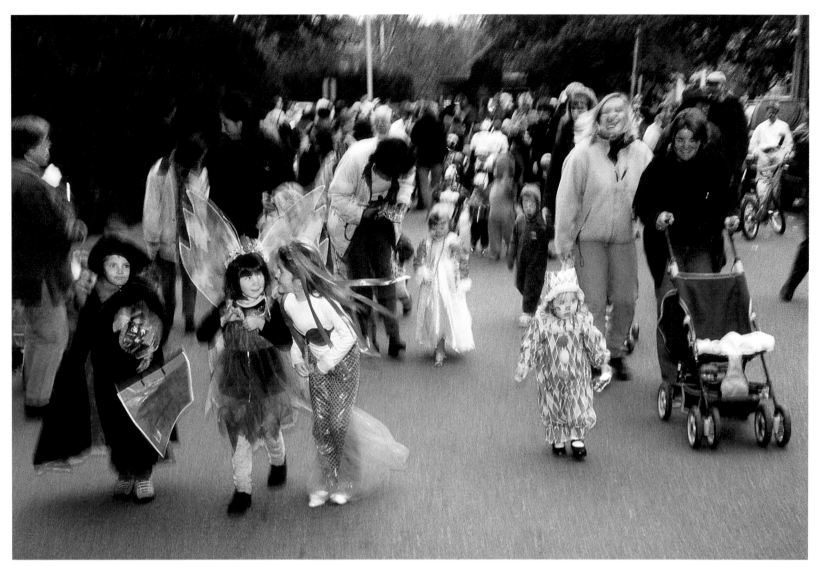

Hubbard Street Halloween Parade

Those Concord days were the happiest of my life, for we had charming playmates in the little Emersons, Channings, Hawthornes, and Goodwins, with the illustrious parents and their friends to enjoy our pranks and share our excursions.

—Louisa May Alcott

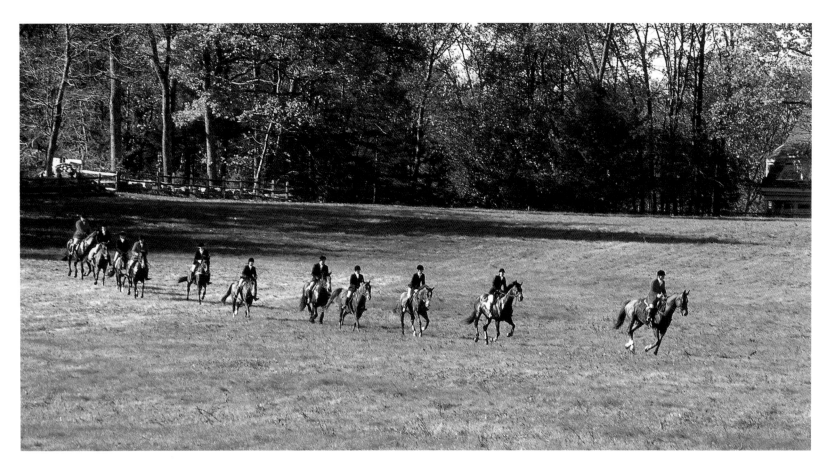

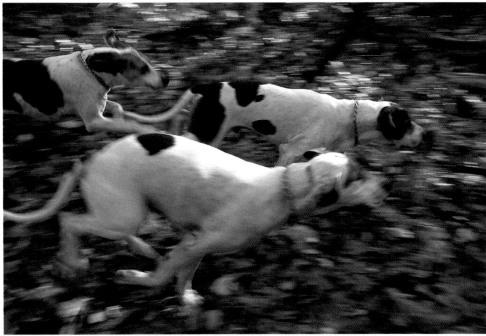

Old North Bridge Hounds Club

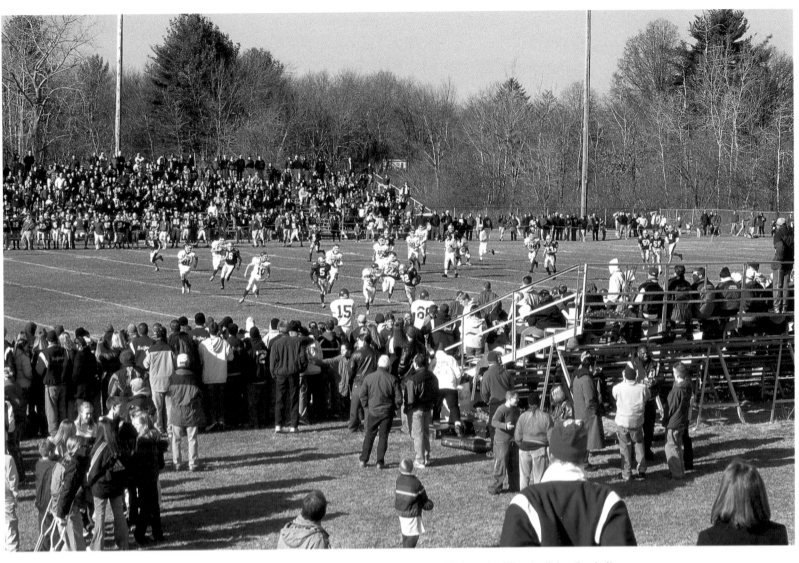

Concord-Carlisle Regional High School takes on Bedford High at the Thanksgiving football game.

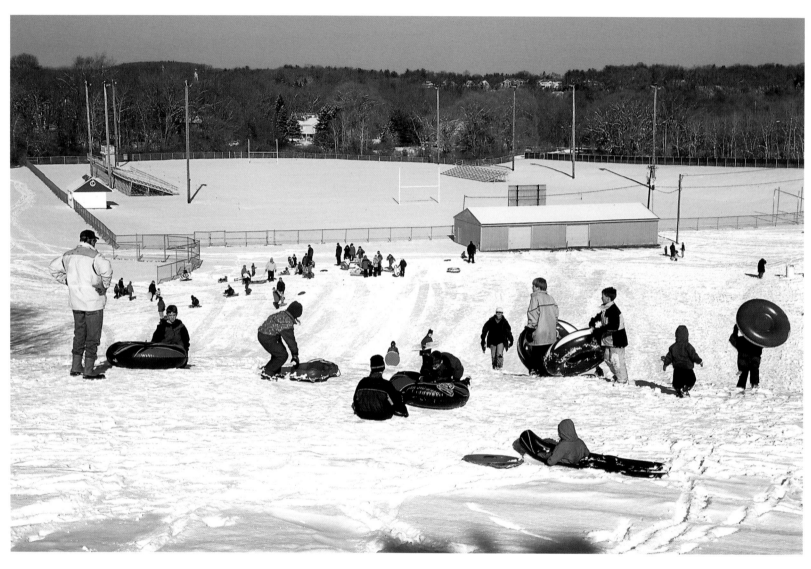

Sledding at the high school hill

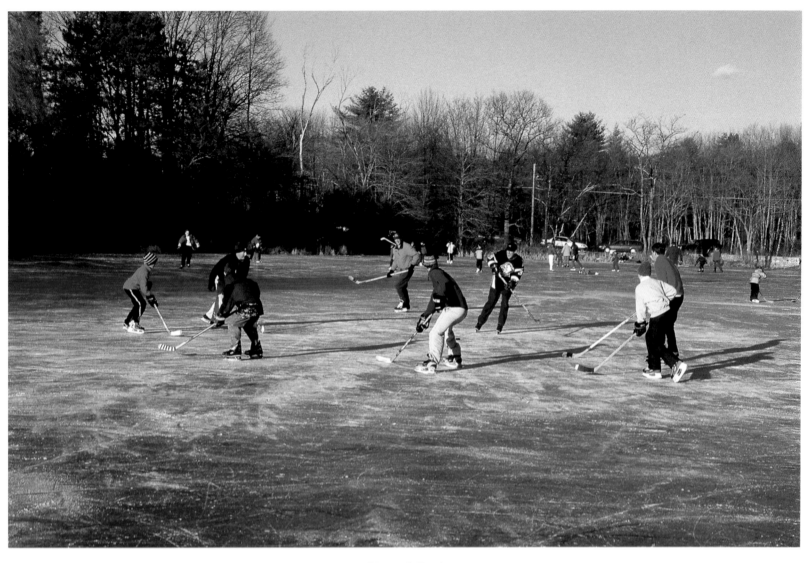

Macone's Pond

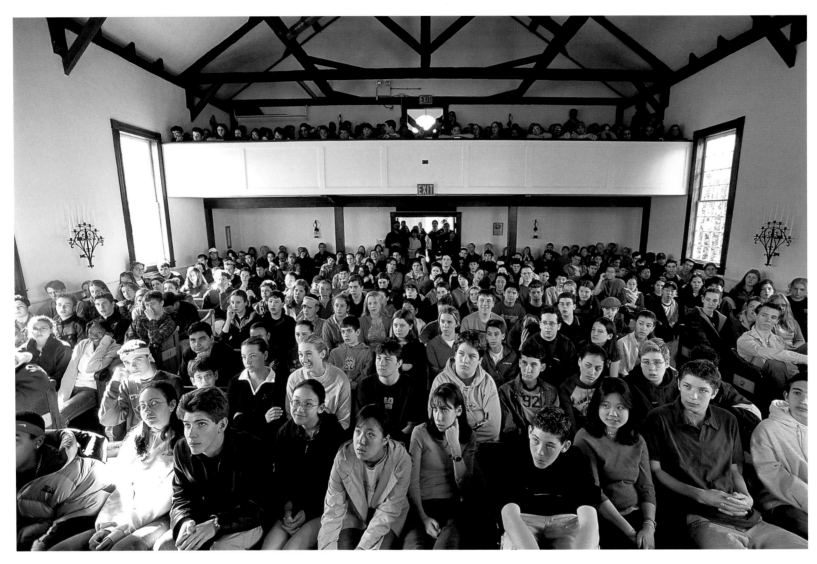

Students and faculty gather for morning announcements in the Elizabeth B. Hall Chapel at Concord Academy.
Chartered in 1922, Concord Academy is a coeducational, college preparatory school for boarding and day students, grades nine through twelve.

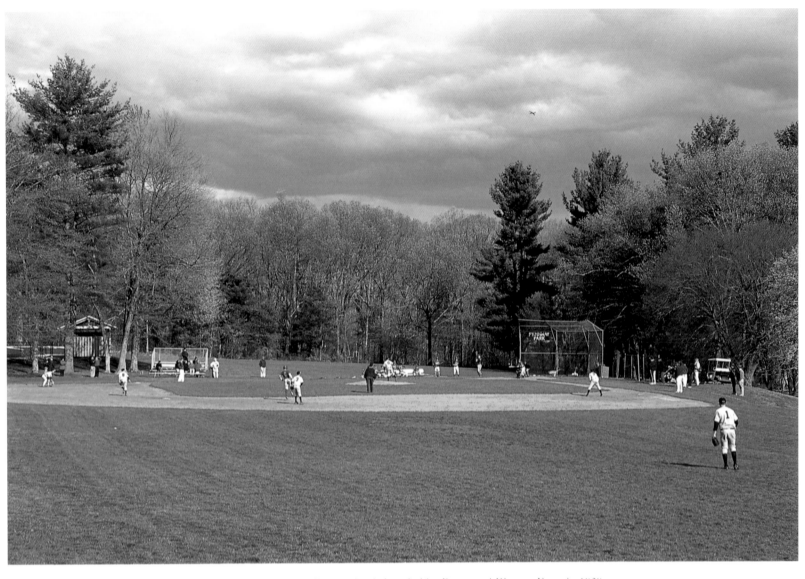

Fennway Park at the Fenn School, founded by Roger and Eleanor Fenn in 1929

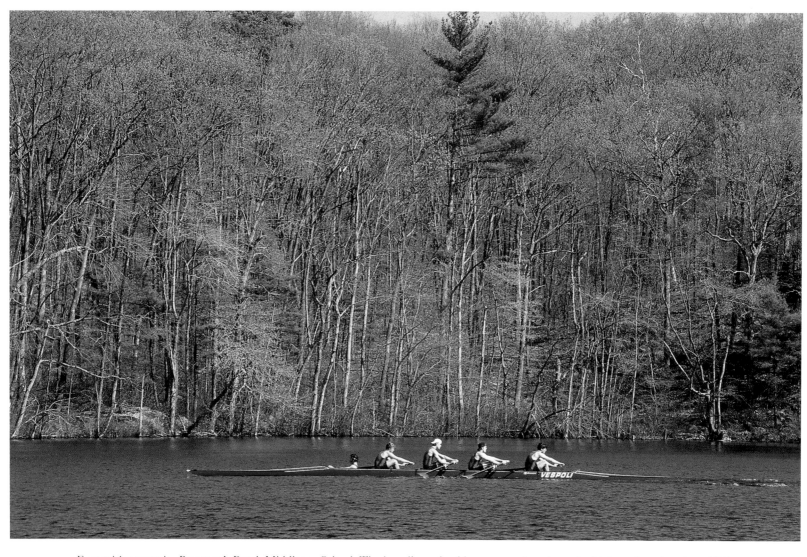

Four with coxswain, Bateman's Pond, Middlesex School. The boarding school has prepared students for higher education since 1901.

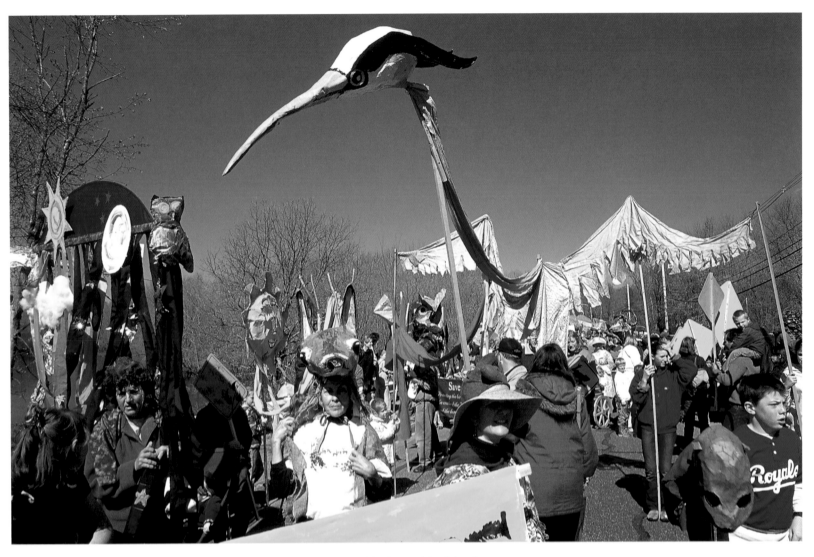

Spring Musketaquid celebration

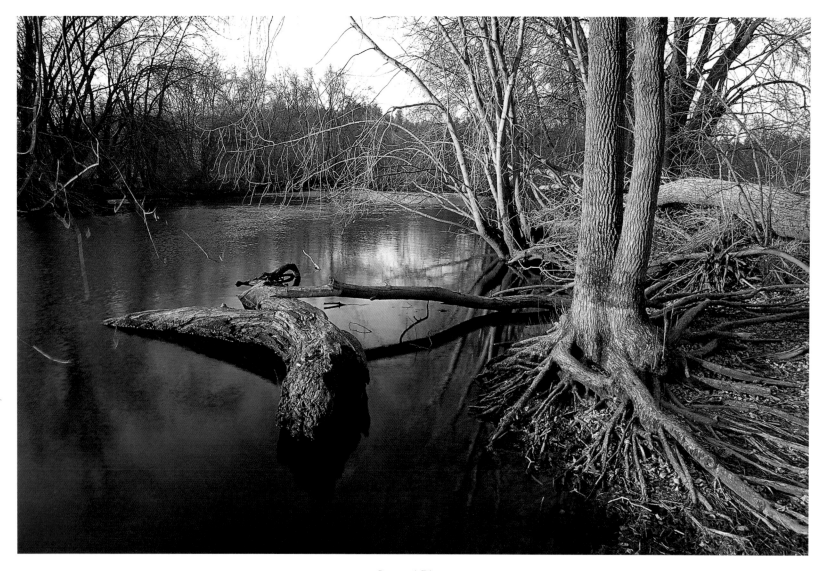

Concord River

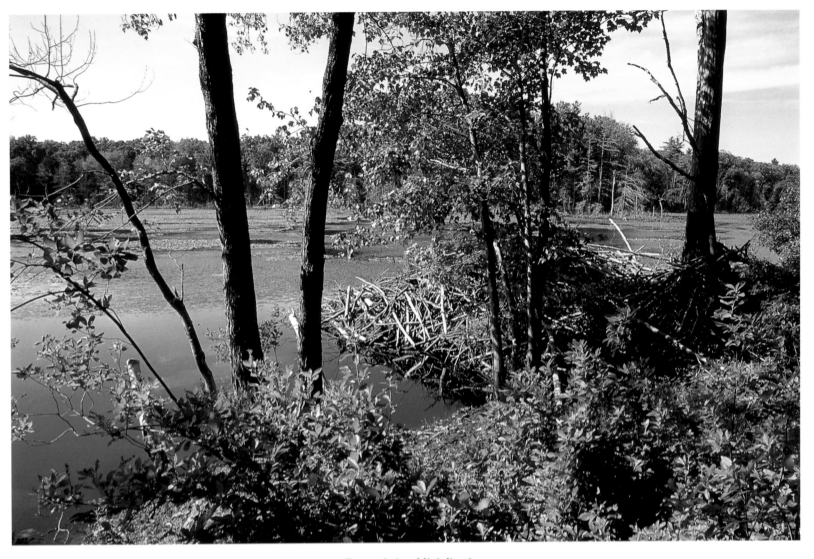

Beaver lodge, Mink Pond

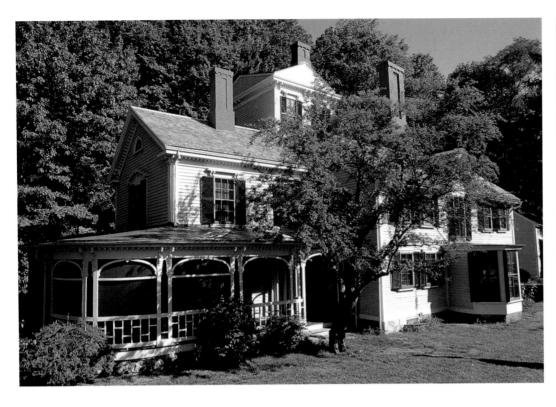

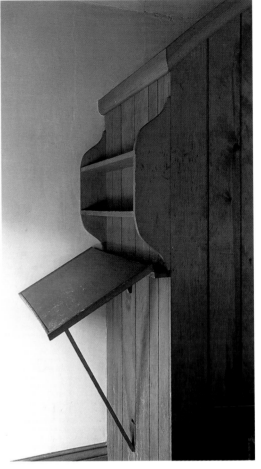

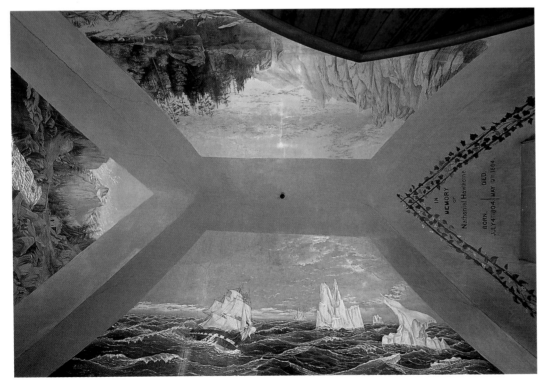

(Top, Left)
The Wayside, which dates to 1717, was the home of the Alcotts, Nathaniel Hawthorne, and Margaret Sidney. It was the only home Hawthorne ever owned.

(Top, Right)
Hawthorne's desk in his study at the Wayside

(Bottom)
Ceiling of Hawthorne's study on the third floor of "the tower," painted as a tribute to him by George Arthur Gray in 1871

I know nothing of the history of this house except Thoreau's telling me that it was inhabited a generation or two ago by a man who believed he should never die. I believe, however, he is dead: at least I hope so; else he may probably appear and dispute my title to his residence.

—Nathaniel Hawthorne

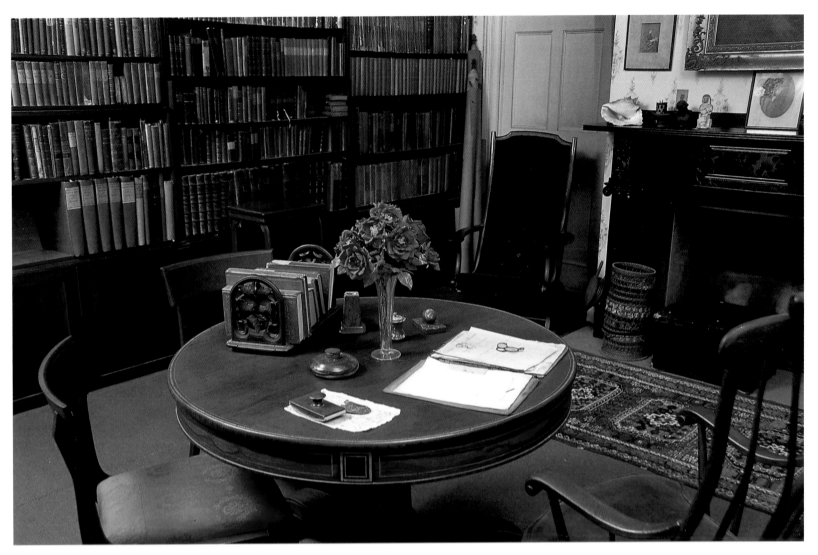

Moved to the Concord Museum in 1930, the Emerson Study is arranged exactly as it was when Ralph Waldo Emerson died in 1882.

When the book mania fell upon me at age fifteen, I used to venture into Mr. E.'s library and ask what I should read, never conscious of the audacity of my demand, so genial was my welcome. . . . I gratefully recall the sweet patience with which he led me around the book-lined room till "the new and very interesting book" was found.

—Louisa May Alcott

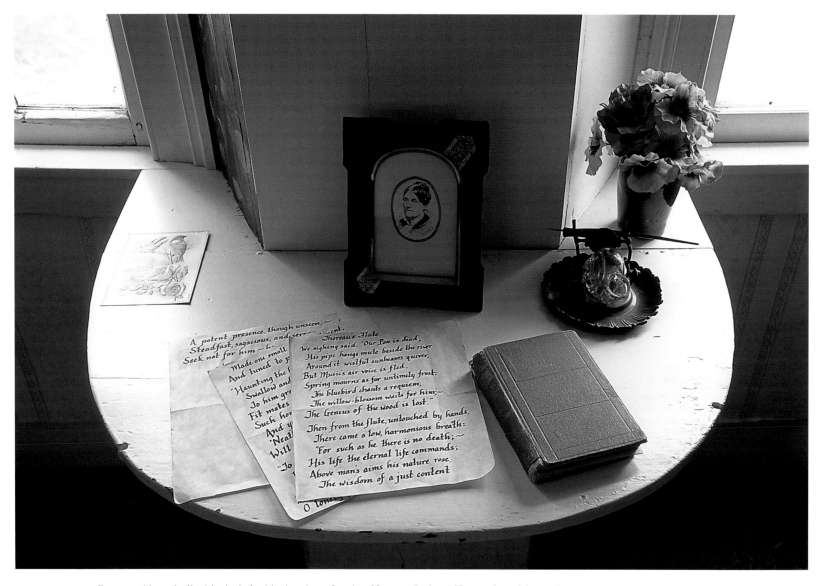

Bronson Alcott built this desk for his daughter, Louisa. Here at Orchard House, from May to July 1868, she wrote *Little Women*.

Concord is where I grew up under the influence of the writings of Louisa May Alcott. My mother said there was an excruciating period when I called her Marmee and helped with the dishes all the time.

—Sarah Payne Stuart, author

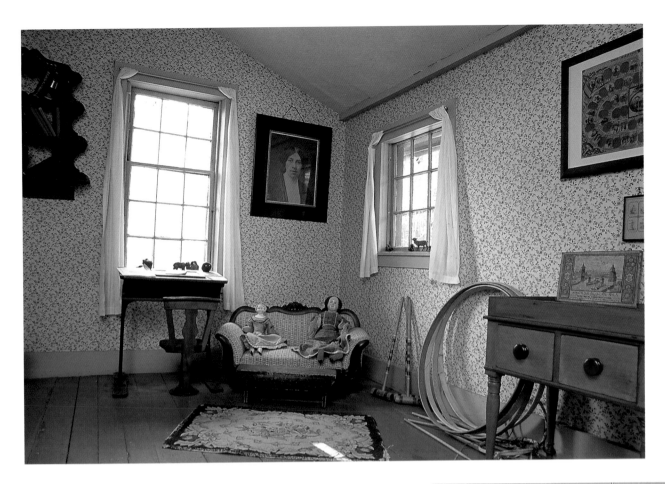

(*Top*)
The nursery,
Orchard House

(*Bottom*)
May, the youngest of the four
Alcott girls, practiced her art
on walls and a door at
Orchard House, the family's
home from 1858 to 1877.

*Over 50,000 visitors come to Orchard House every
year, attracted to the comfort and beauty of the Alcotts'
family love. Those who tour inside the home are often
surprised to learn that the Alcotts were not the
sentimental family they expected. The members of the
family were the models for "Little Women," but they
also expressed love in daring social action, the arts,
literature and philosophy.*

Jan Turnquist, executive director,
Orchard House, home of the Alcotts

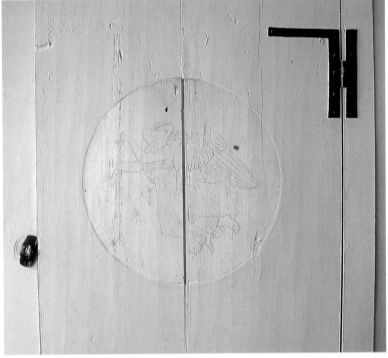

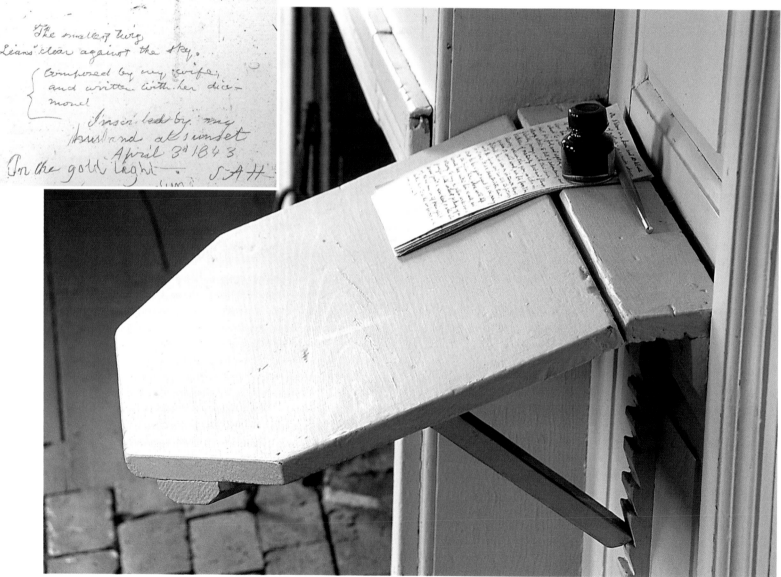

(Top) Using her diamond ring, Sophia Hawthorne wrote on window glass at the Old Manse—which the owners of the home, the Ripleys, viewed as "a horrible defacement."

(Bottom) Hawthorne's desk at the Old Manse, where he and Sophia lived from 1842 to 1845

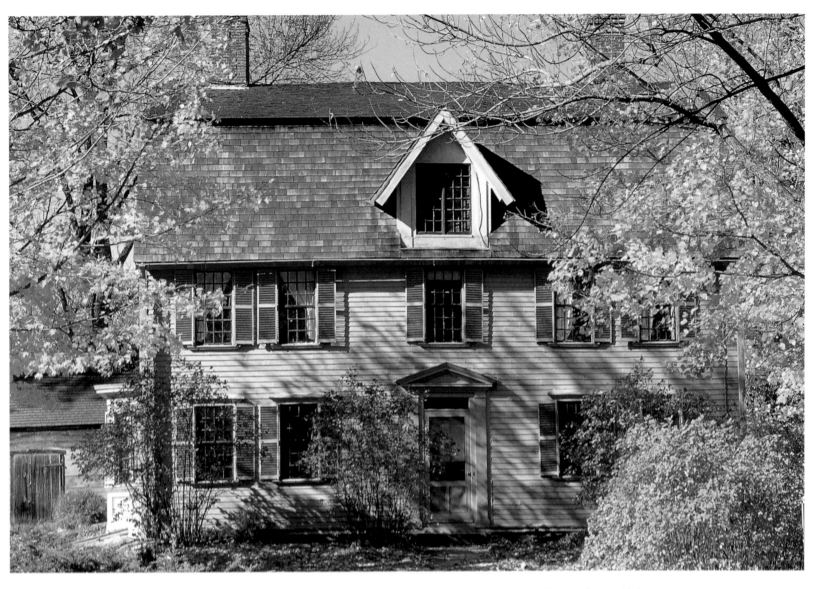

The Old Manse, built in 1770 for the Reverend William Emerson (Ralph Waldo Emerson's grandfather).
Hawthorne gave it its name, using the Scottish word for a minister's home. It is owned and cared for by The Trustees of Reservations.

The Concord School of Philosophy, a lifelong dream of transcendentalist A. Bronson Alcott, established in July 1879

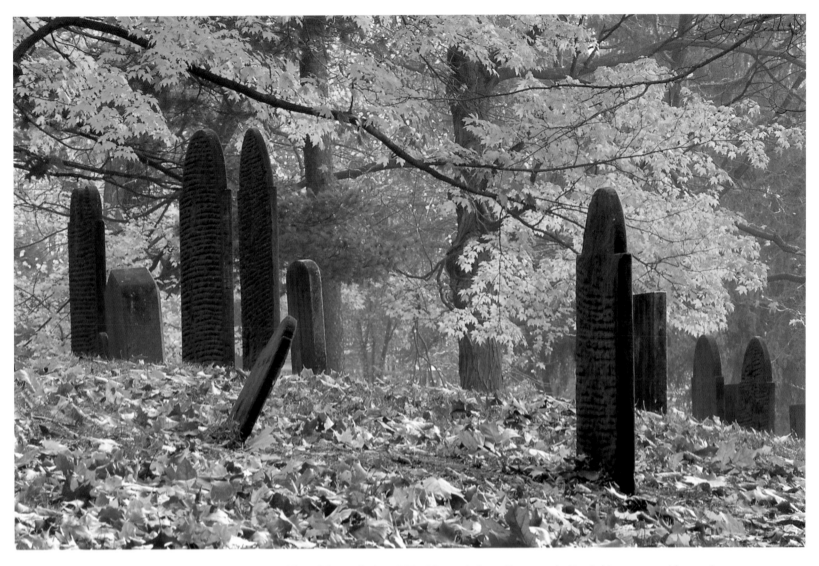

Sleepy Hollow Cemetery, consecrated in 1855, was designed like Mount Auburn Cemetery in Cambridge to resemble a park.

Sleepy Hollow. In this quiet valley, as in the palm of Nature's hand, we shall sleep well when we have finished our day.

—Ralph Waldo Emerson

A man should carry Nature
in his head—should know
the hour of the day or
night, and the time of year,
by the sun and stars;
should know the solstice
and the equinox, the
quarter of the moon and
the daily tides.

—Ralph Waldo Emerson

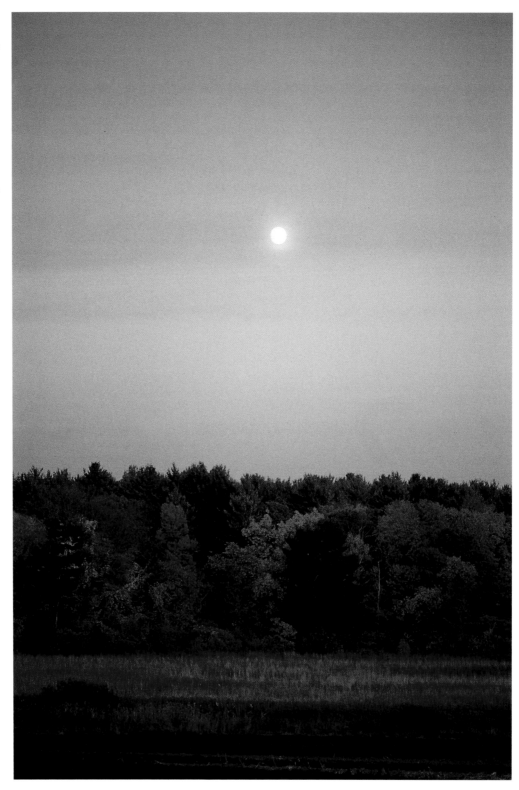

Moonrise over Willow Guzzle Reservation, Sudbury Road

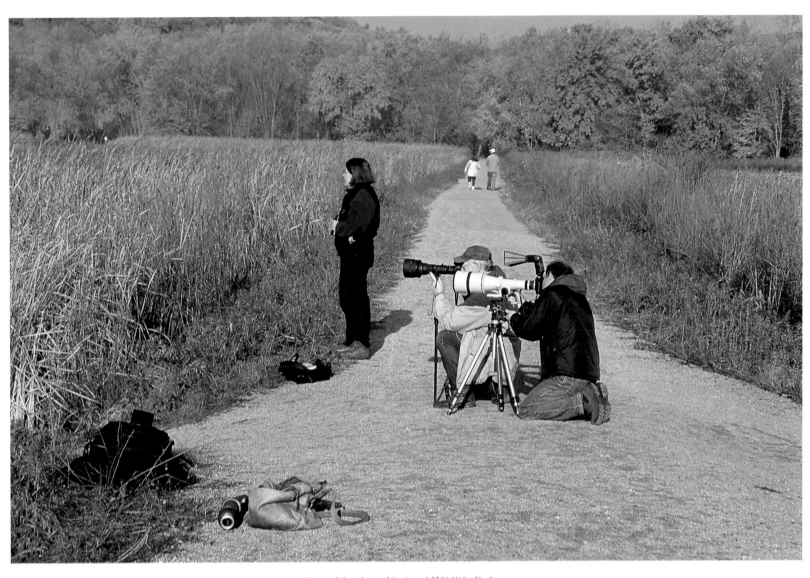

Great Meadows National Wildlife Refuge

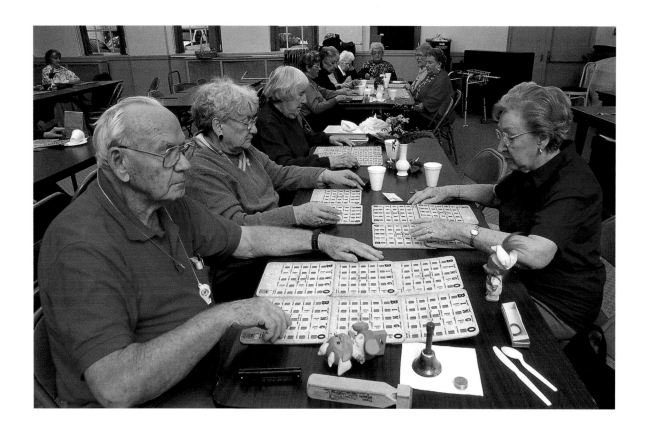

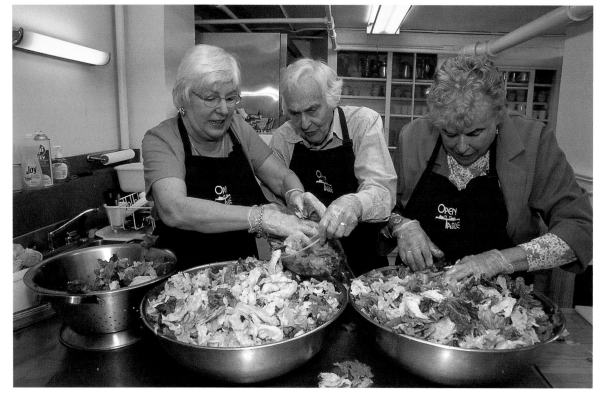

(Top)
Bingo, Council on
Aging, Harvey
Wheeler Center

(Right)
Volunteers Lyneath
Floyd, Ida Aronie, and
Rosemary Mrakovich
prepare food at Open
Table, which provides
a food pantry and
serves dinner to all
who come every
Thursday at the First
Parish Church.

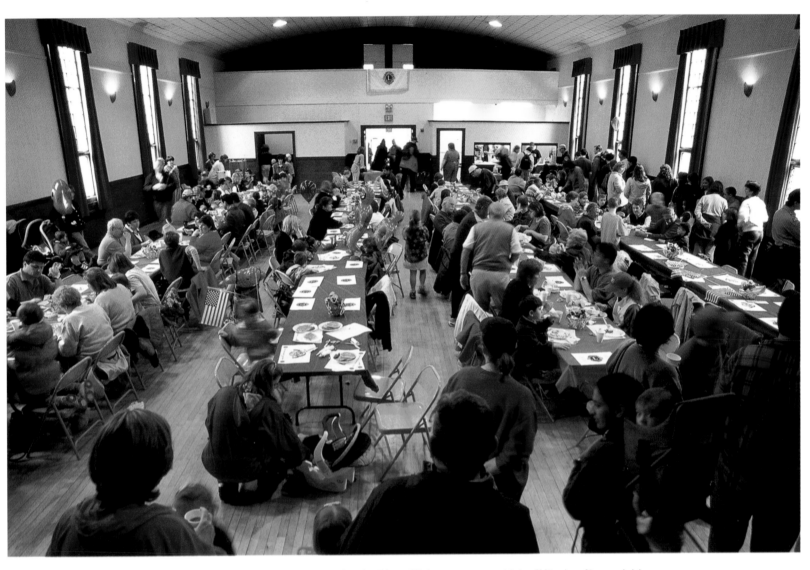

Traditional pancake breakfast put on by the Lions Club every year to kick off Patriots Day activities

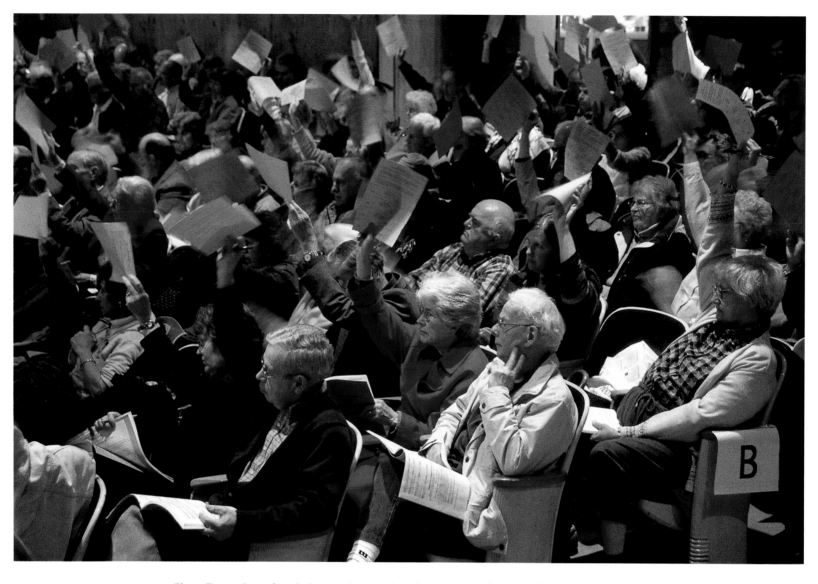

Since Concord was founded, voters have gathered at town meeting to decide the town's affairs.

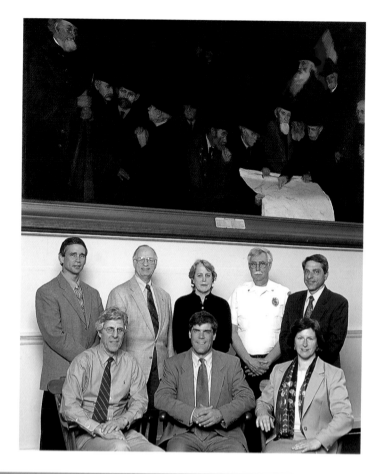

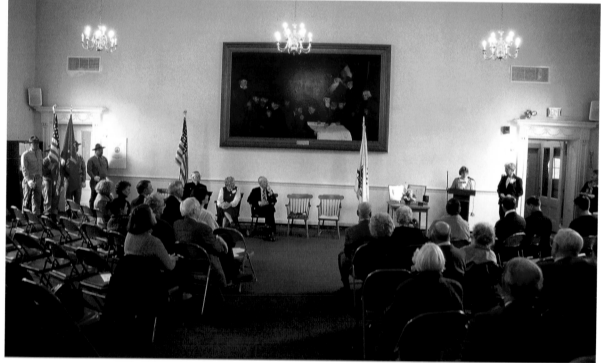

(Top)
Town department heads.
Standing, left to right:
Doug Meagher, assistant
town manager; Dan Sack,
Concord Municipal Light
Plant; Barbara Powell,
library director; Joe
Lenox, fire chief;
Anthony Logalbo, finance
director. *Seated:* Bill
Edgerton, public works
director; Chris Whelan,
town manager; Marcia
Rasmussen, planning
director.

(Bottom)
Honored Citizen
Award Ceremony,
Town Hall. Elaine
DiCicco, retired principal
of Concord-Carlisle
Regional High School,
was the recipient in 2002.

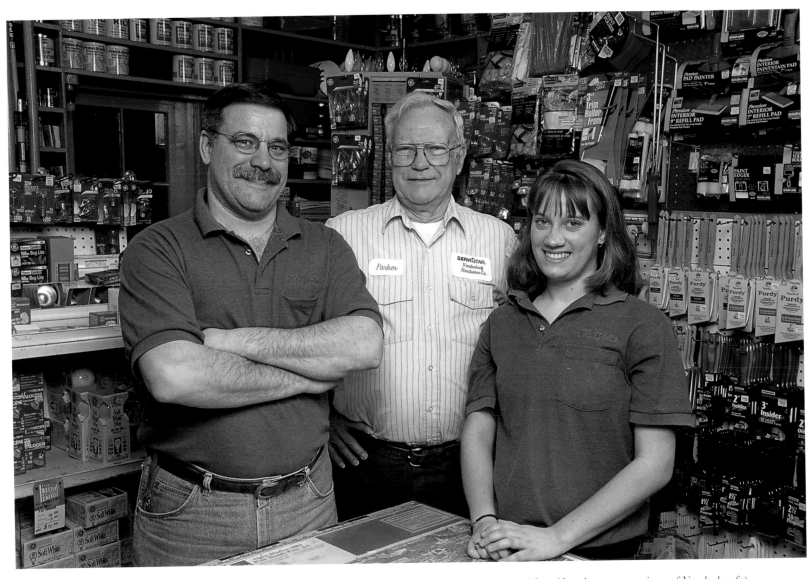

Vanderhoof Hardware, a presence on the Milldam since 1904. (*Left to right:* Scott, Parker, and Jennifer, three generations of Vanderhoofs)

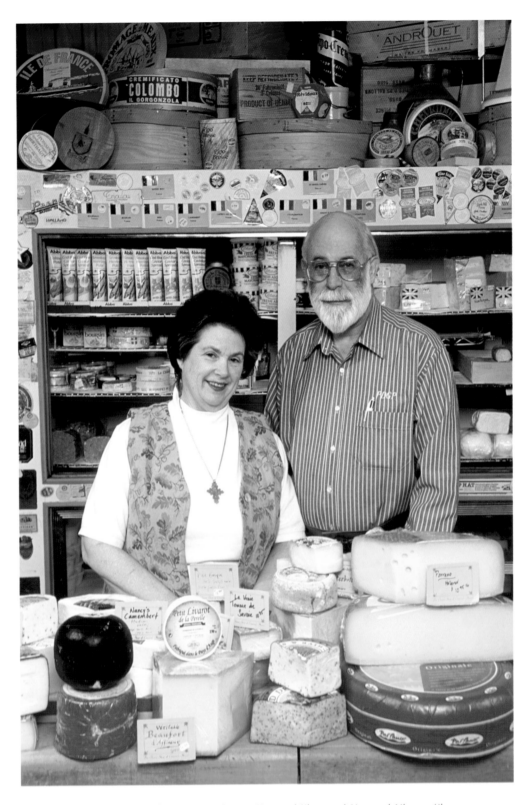

Louise and Bill Barber, proprietors, Concord Shop and Concord Cheese Shop

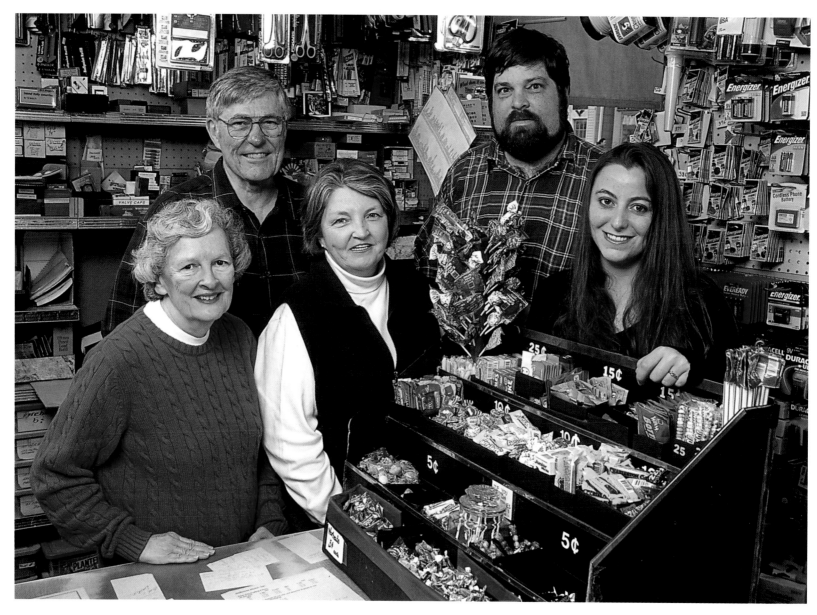

Maynard Forbes, second from left, and staff of the West Concord 5 & 10. First opened in 1935, the store has been owned by the Forbes family since 1951.

If you start here, it may save you mountains of time looking for the everyday things you need.

—Maynard Forbes

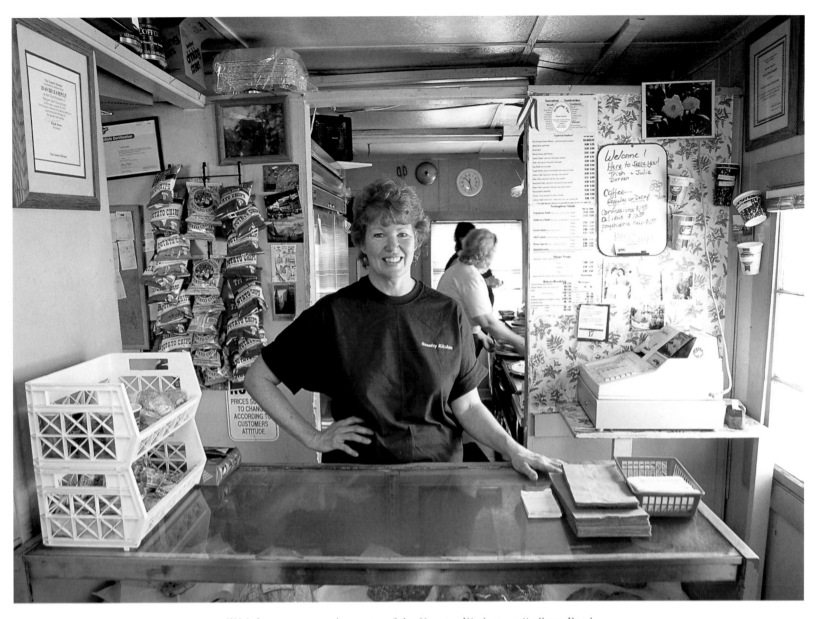

Trish Irons, owner and operator of the Country Kitchen, on Sudbury Road

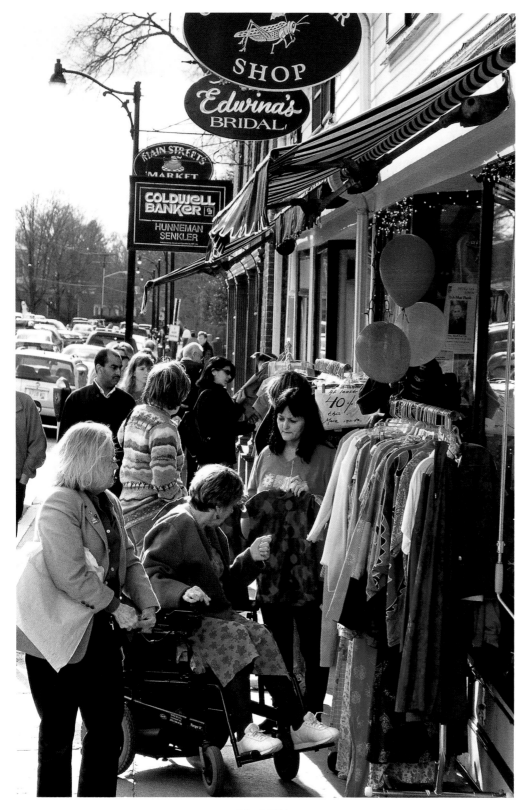

The Milldam

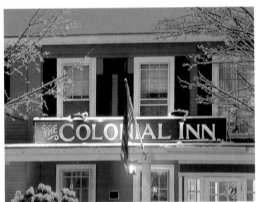

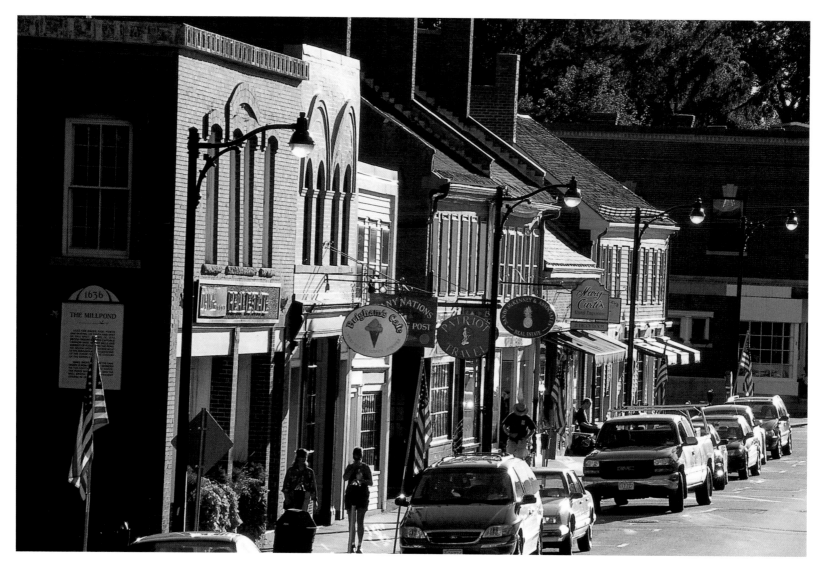

Main Street

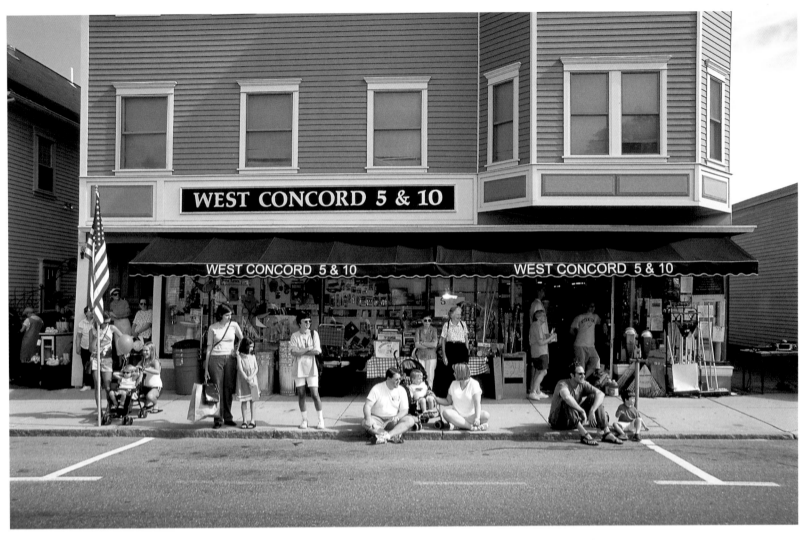

Waiting for the parade at the West Concord Family Festival, held each September

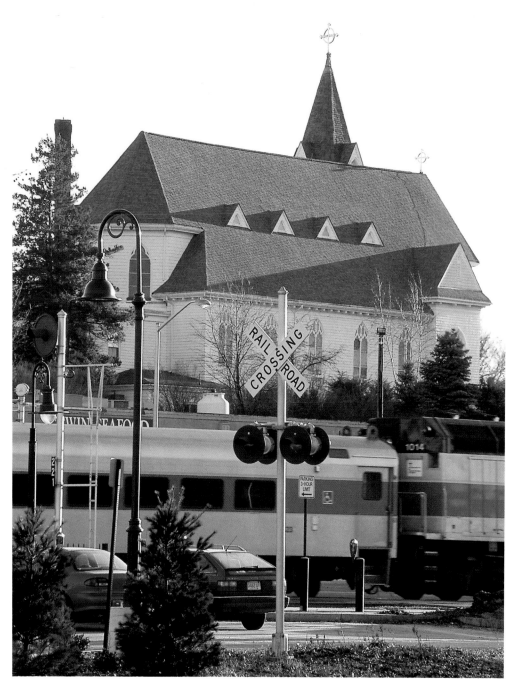

West Concord

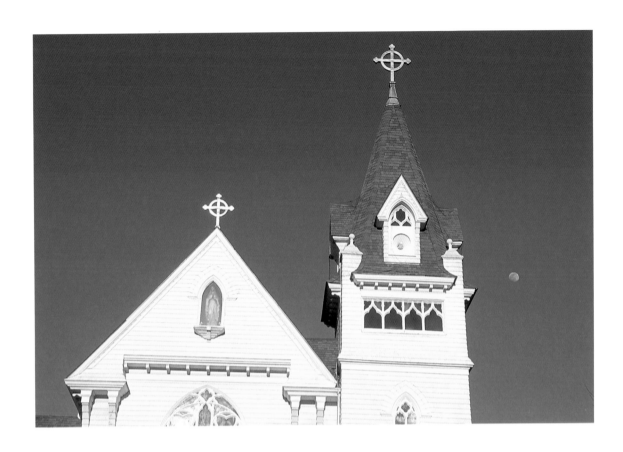

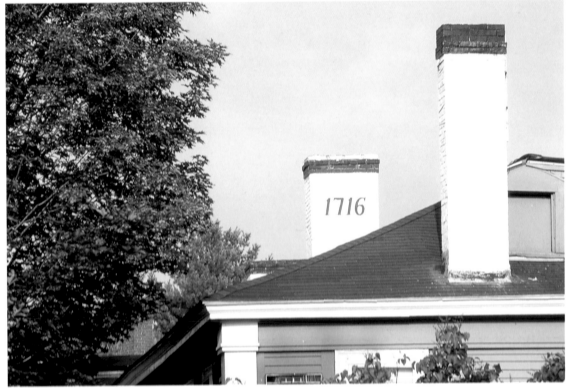

(Top)
Our Lady
Help of Christians
Catholic Church

(Bottom)
The Colonial Inn,
which stands
on part of the land
owned by the
Reverend Peter
Bulkeley, Concord's
first minister and
Ralph Waldo
Emerson's ancestor.
The east end of the
inn was built in 1716.

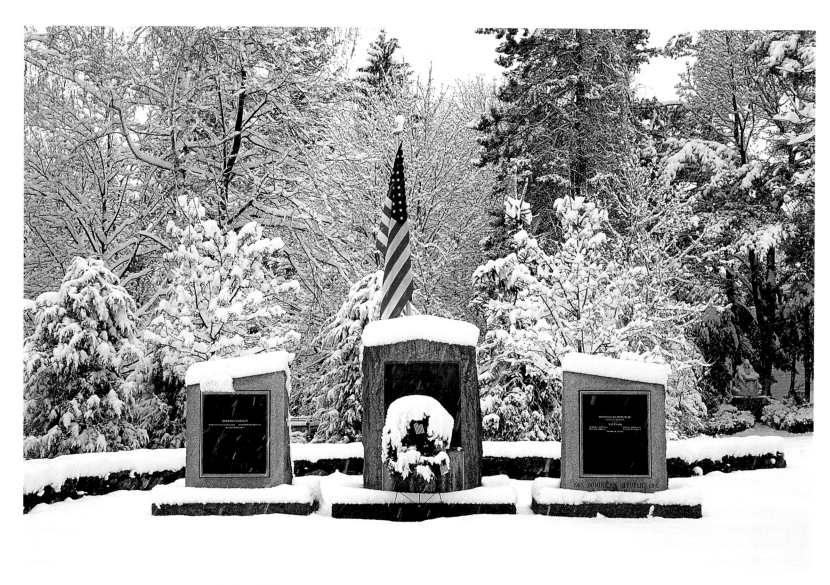

"A Grateful Community dedicates this memorial to those who served our country"
in World War II, the Korean Conflict, the Dominican Republic, and Vietnam.

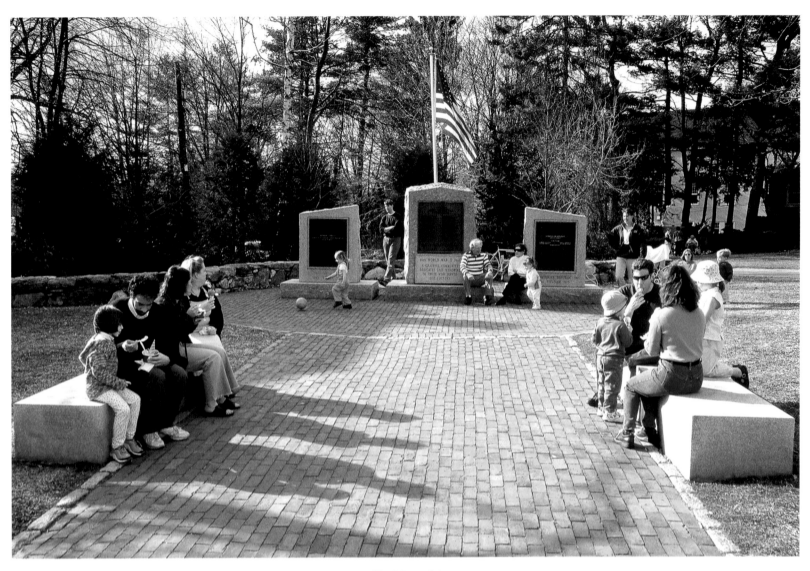

War Memorial

The Old Courthouse at 30 Monument Square, built in 1850.

First Parish Church, site of the First and Second Provincial Congress in 1774. The present structure was built in 1901.

Trinitarian Church, built in 1926

Obelisk in Monument Square,
"dedicated to those who died in the War of the Rebellion"

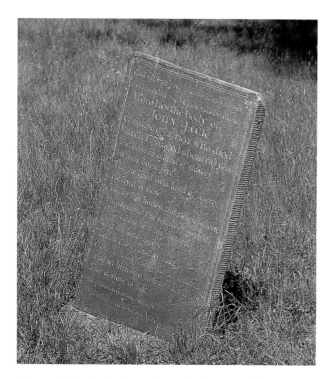

Grave of John Jack, former slave, in the upper left corner of the Old Hill Burying Ground. The epitaph by Tory Daniel Bliss of Concord reads:

God wills us free; man wills us slaves.
I will as God wills; God's will be done.
 Here lies the body
 JOHN JACK
A native of Africa who died
March 1773, aged about 60 years.
Tho' born in a land of slavery,
He was born free.
Tho' he lived in a land of liberty,
He lived a slave.
Till by his honest, tho' stolen labors,
He acquired the source of slavery,
Which gave him his freedom;
Tho' not long before
Death, the grand tyrant,
Gave him his final emancipation,
And set him on a footing with kings.
Tho' a slave to vice,
He practised those virtues
Without which kings are but slaves.

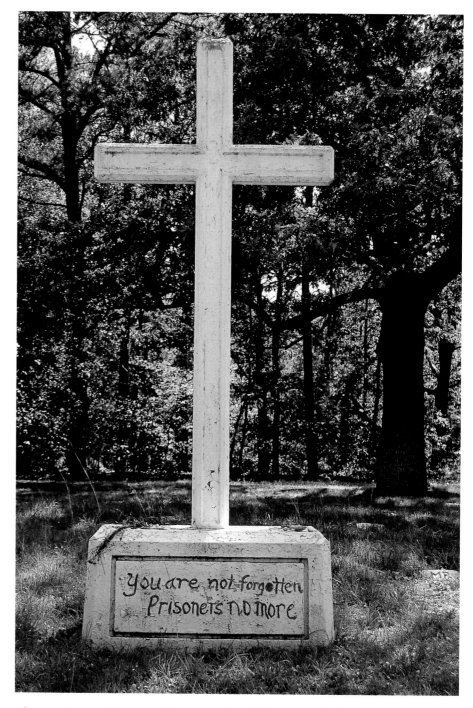

Gravemarkers, MCI-Concord. In 2001 an interfaith group added inmates' names to the 217 markers. Prisoners who died while incarcerated between 1878 and 1996 had been identified only by number.

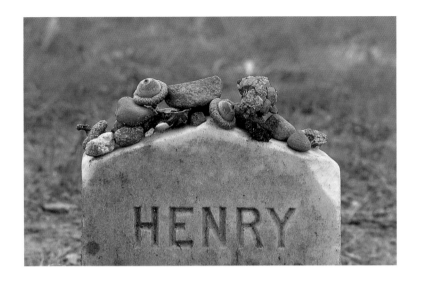

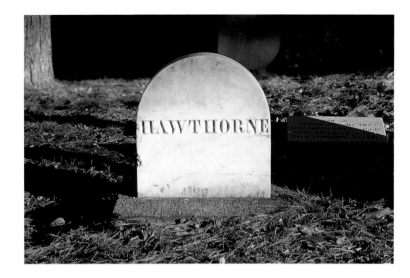

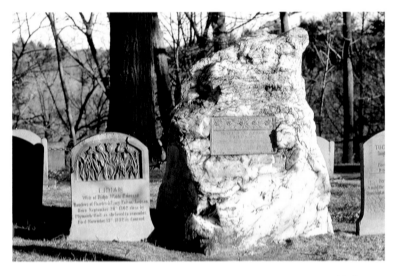

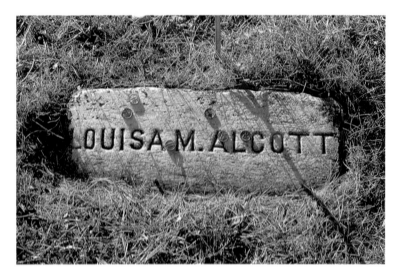

(Top) Grave of Henry David Thoreau, Authors' Ridge, Sleepy Hollow Cemetery. Thoreau was first buried at the New Burying Ground on Bedford Street, but some time before 1874 his remains were moved here.

(Bottom) Ralph Waldo Emerson's grave, Authors' Ridge

(Top) Nathaniel Hawthorne's grave, Authors' Ridge

(Bottom) Louisa May Alcott's grave, Authors' Ridge

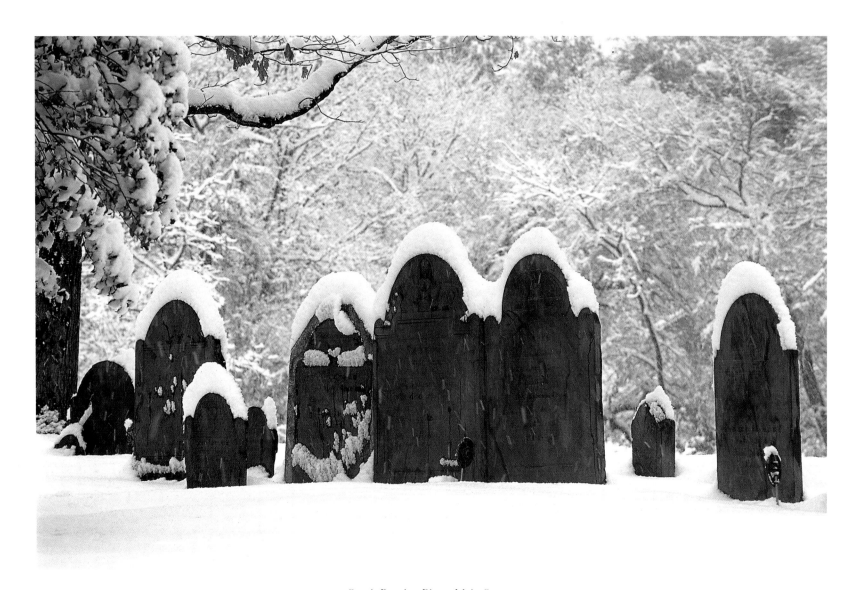

South Burying Place, Main Street

Christmas decorations, Bedford Road

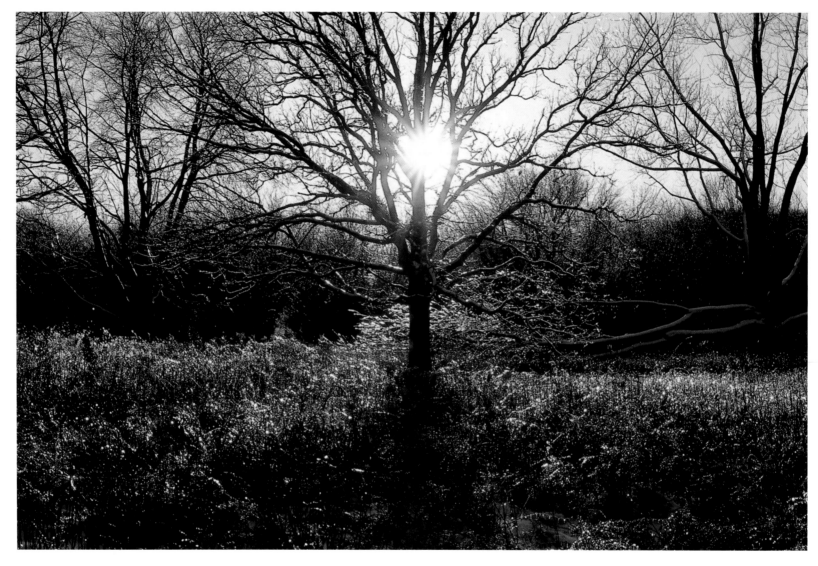

Old Calf Pasture

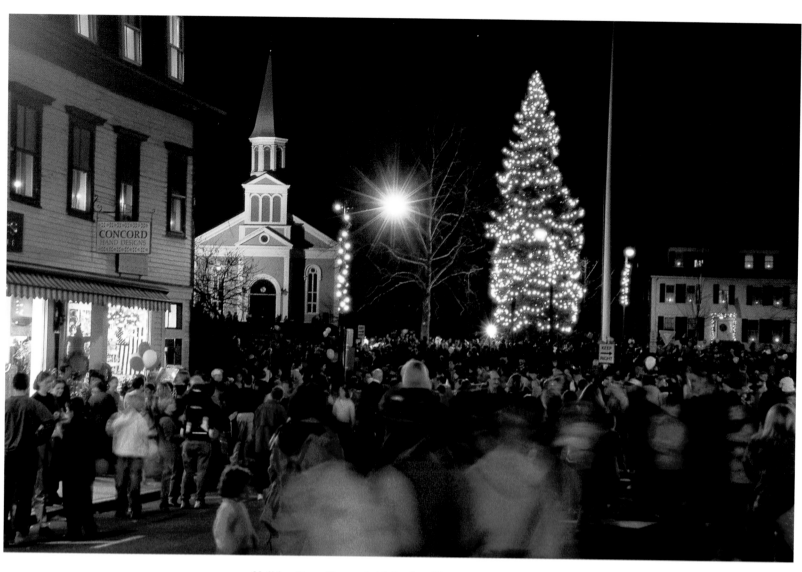

Holiday Open House, held the first Thursday of December

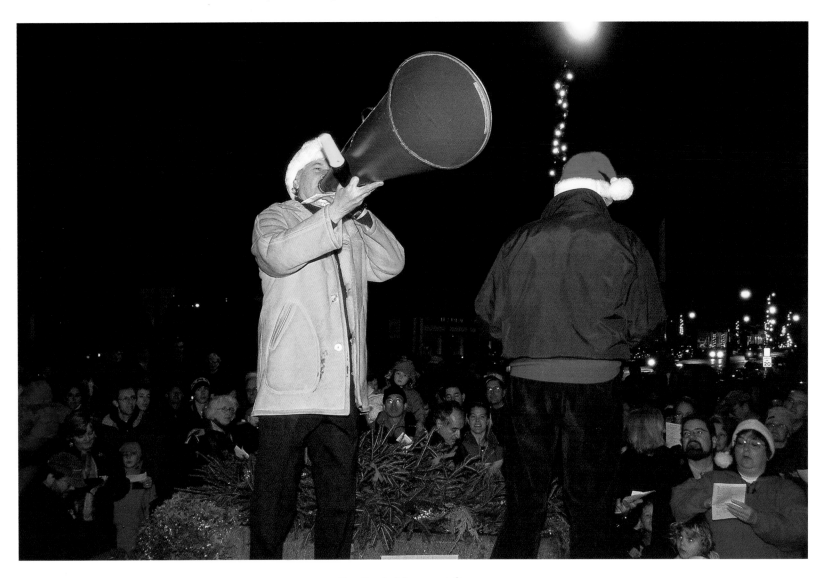

Caroling in Monument Square

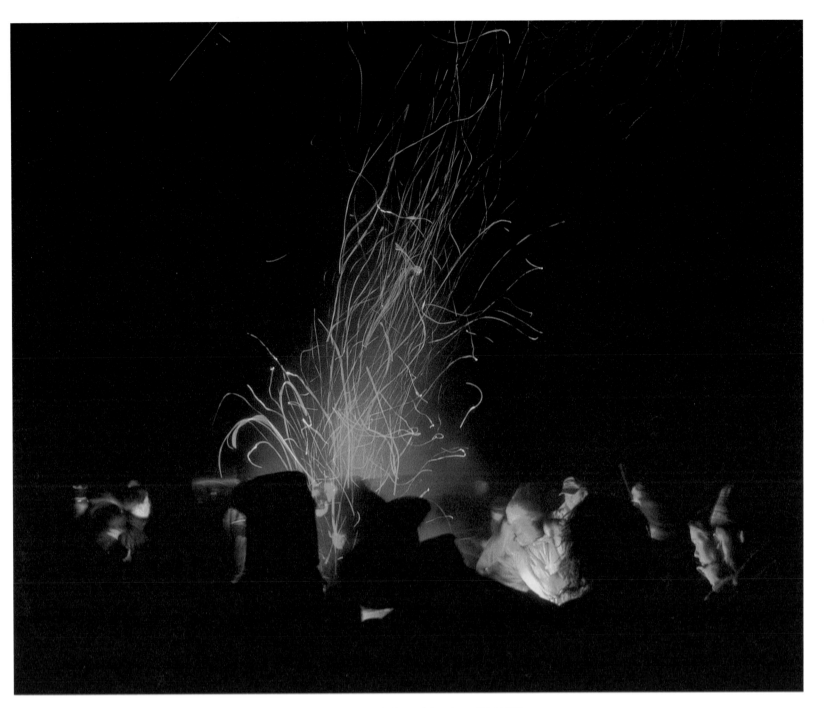

Musketaquid winter solstice celebration, Old Calf Pasture

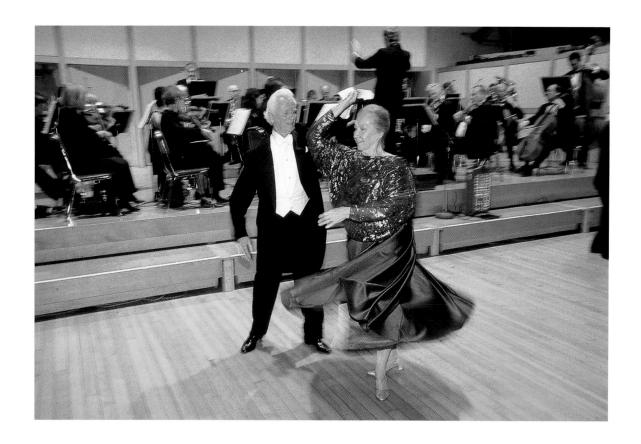

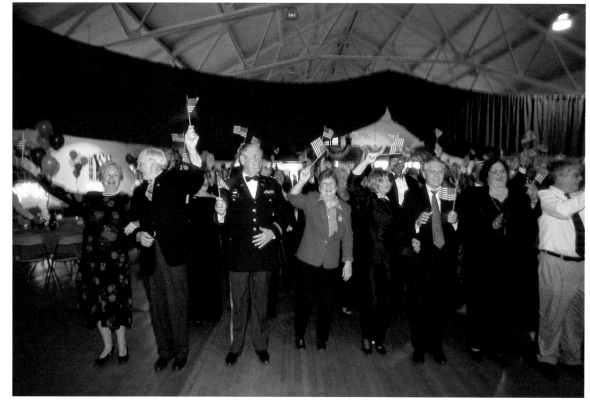

(Top)
Waltz Evening, held
annually since 1981
to benefit the
Friends of the
Performing Arts,
51 Walden Street

(Bottom)
The Patriots Ball,
held annually at the
Armory

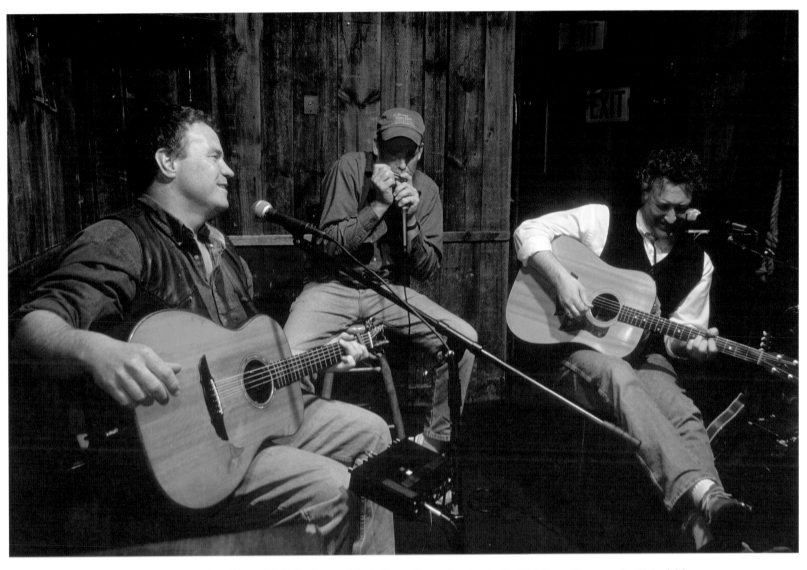

John Fitzsimmons, Pat "Hatrack" Gallagher, and Seth Connelly performing in the Old Forge Room at the Colonial Inn

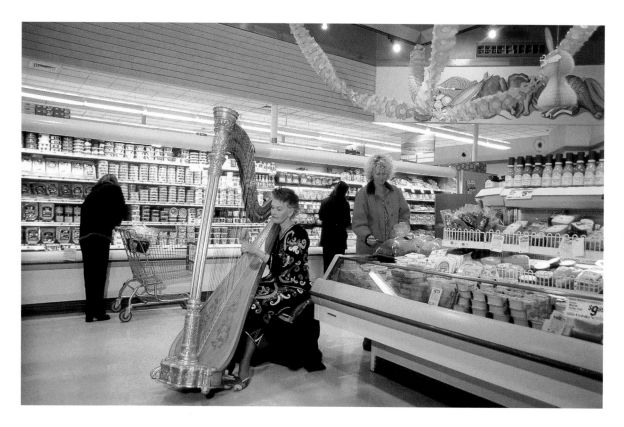

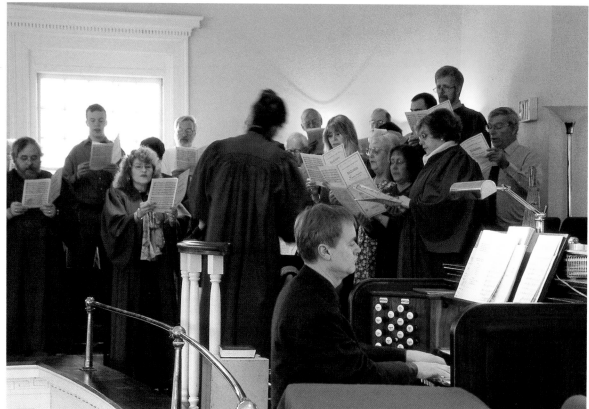

(Top)
Nina Vickers,
harpist, performing at
Crosby's Marketplace

(Right)
Organist D. Eric
Huenneke and choir,
First Parish Church

112

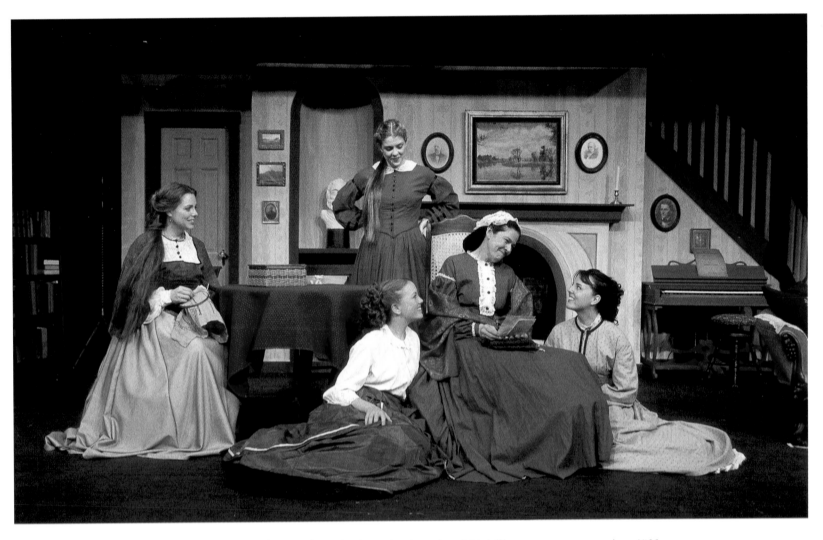

The Concord Players have performed a dramatic adaptation of *Little Women* every ten years since 1932.

I grew up with the Concord Players. My Uncle Ripley Gage, my mother (costume lady), and my father (a singer) were all involved.

—Heddie Kent, who struck her first set for the Concord Players in 1925

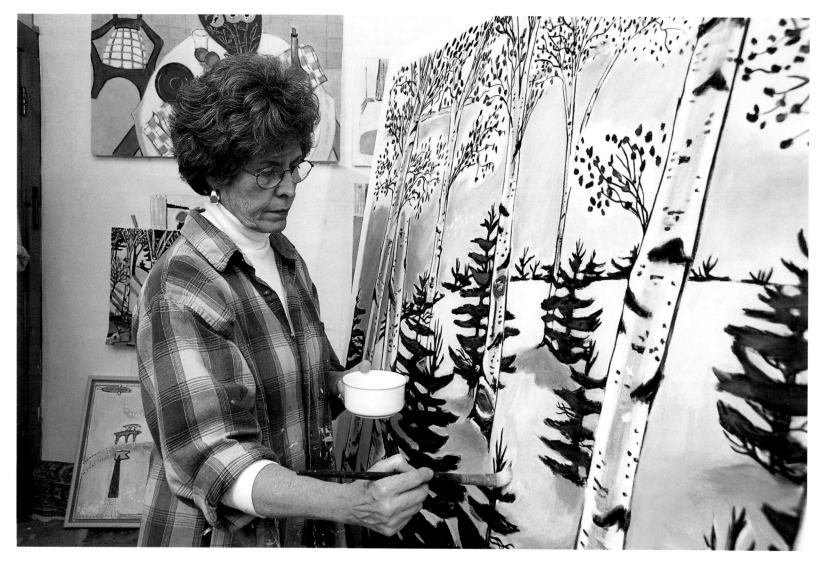

Jane Dahmen, painter. The Emerson Umbrella was established as an art center in 1983 in what was once the Emerson School. Over sixty artists—painters, writers, potters, woodworkers, sculptors, and jewelers among them—work here in their studios.

The Emerson Umbrella Center for Arts is a building bursting with energy, where we share and support one another's attempt at self-expression.

—Jane Dahmen

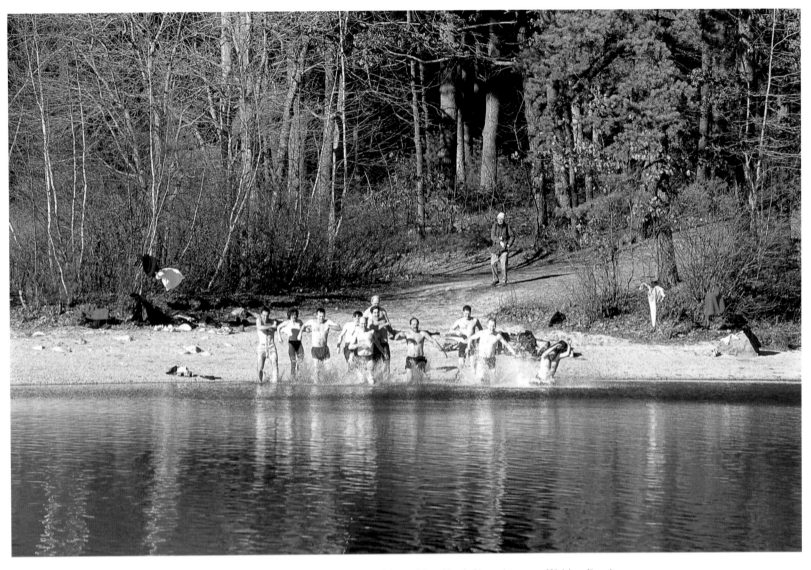

Members of the Concord Runners taking a New Year's Day plunge at Walden Pond.

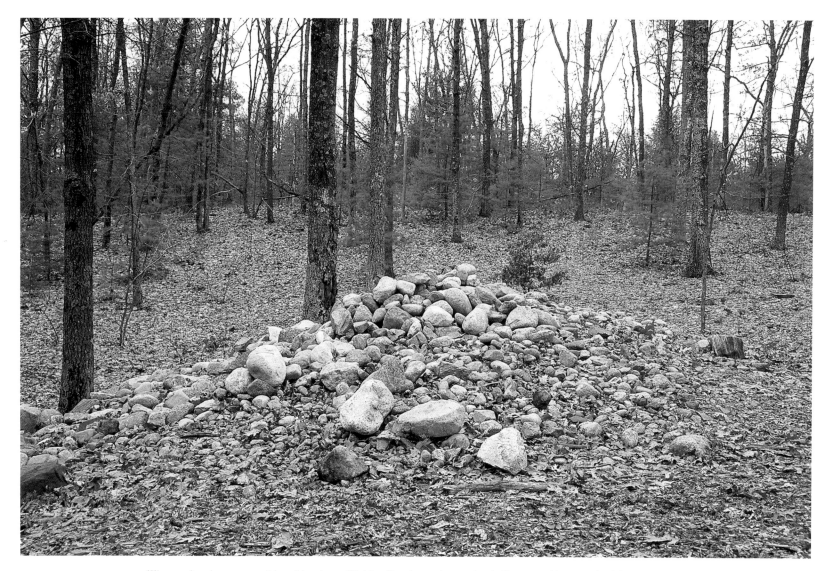

Thoreau's cairn, next to his cabin site at Walden Pond, was begun by A. Bronson Alcott and a friend in 1872.

It will be long before there comes his like; the most sagacious and wonderful Worthy of his time, and a marvel to coming ones.

—A. Bronson Alcott

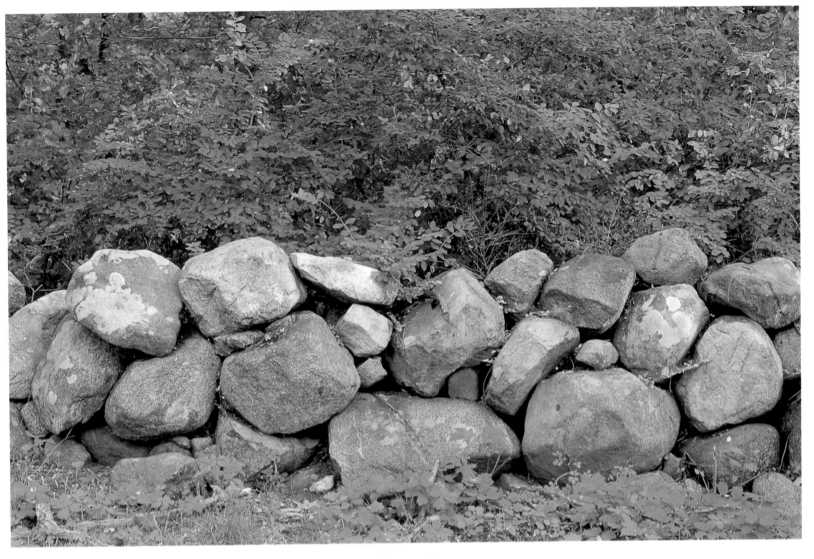

Stone wall

"I took the path that Thoreau often trod . . . down the 'devil's stairway,' over rocks, down its craggy sides, now sliding, now hanging by a twig that was anchored firmly to its side on to the bottom of the cliffs."

Joseph Hosmer, 1881.

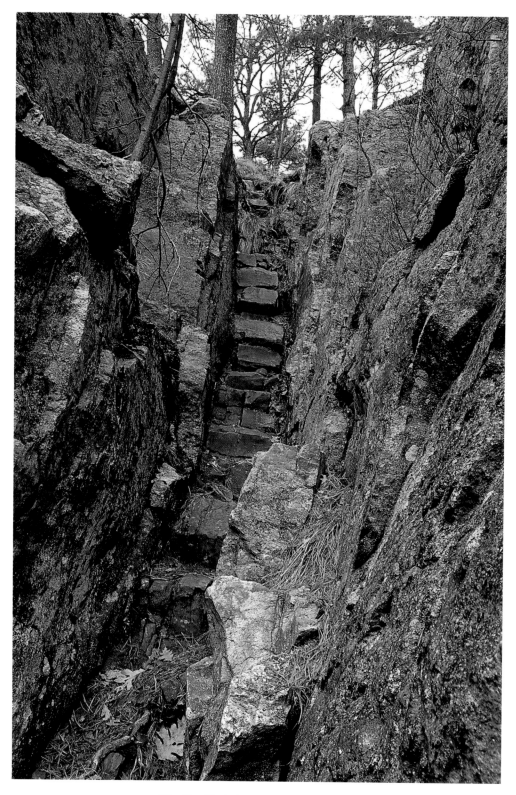

The Devil's Stairway, Fairhaven Woods

Heywood Meadow

Two fawns, Nine Acre Corner

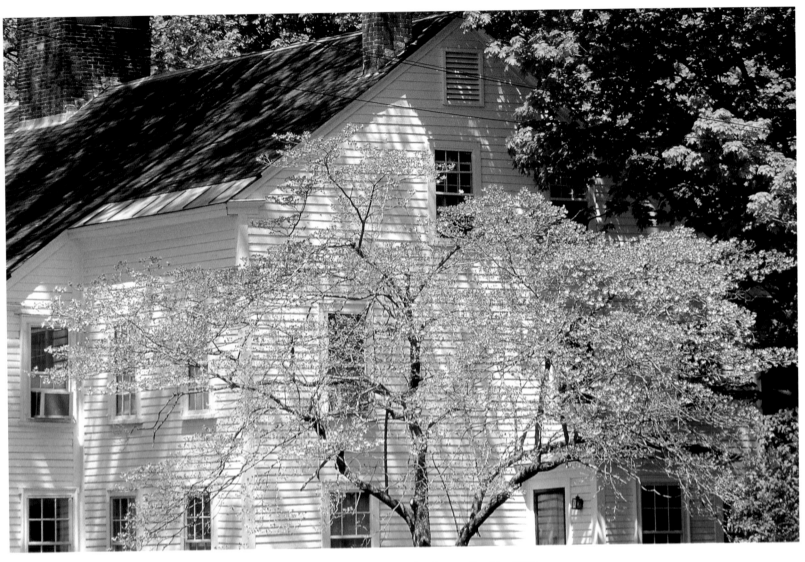

Concord Art Association, 37 Lexington Road (c. 1753)

The Town House, built in 1830, is the seat of town government.

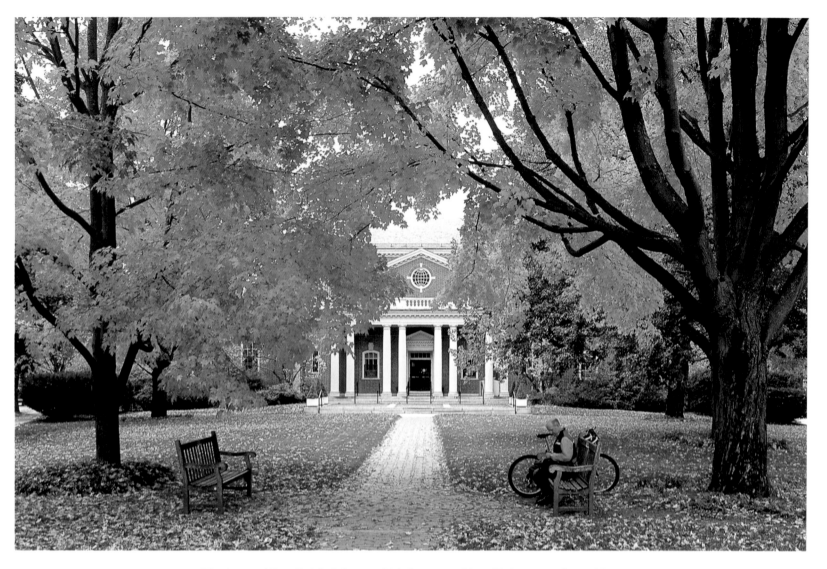

The Concord Free Public Library, which first opened in 1873, has extensive archives
and an original sculpture of Ralph Waldo Emerson by Daniel Chester French.

*In books I have the history
or the energy of the past.*

—Ralph Waldo Emerson

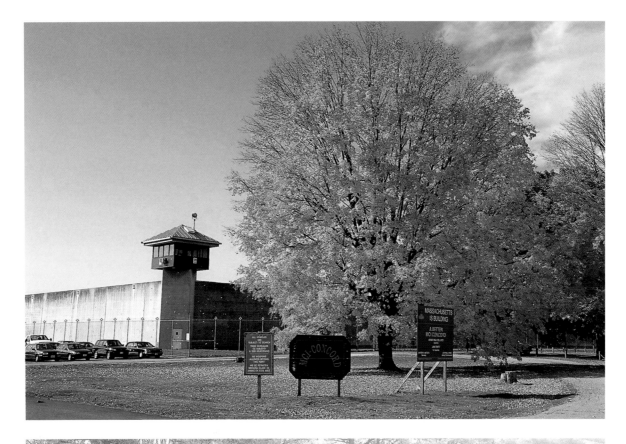

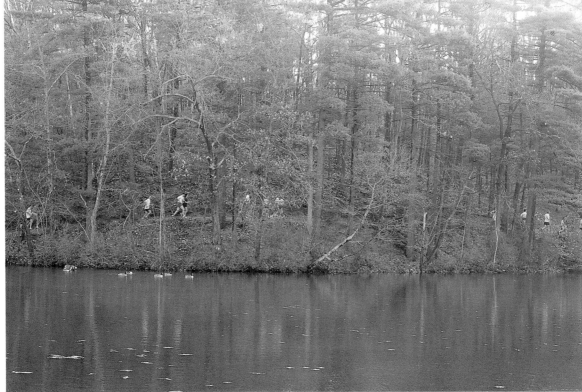

(Top)
"The Big House,"
now MCI-Concord.
When it opened in
1878, it was a
reformatory, where
inmates were taught a
trade.

(Bottom)
Concord Runners
at Fairyland
(Hapgood-Wright
Town Forest)

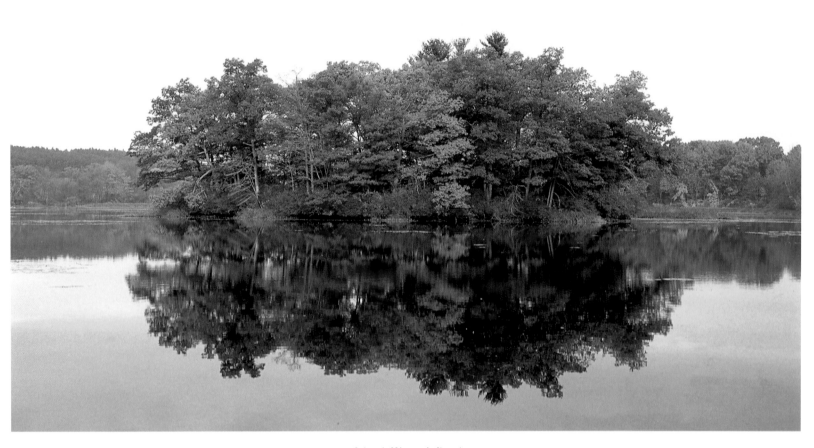

Island, Warner's Pond

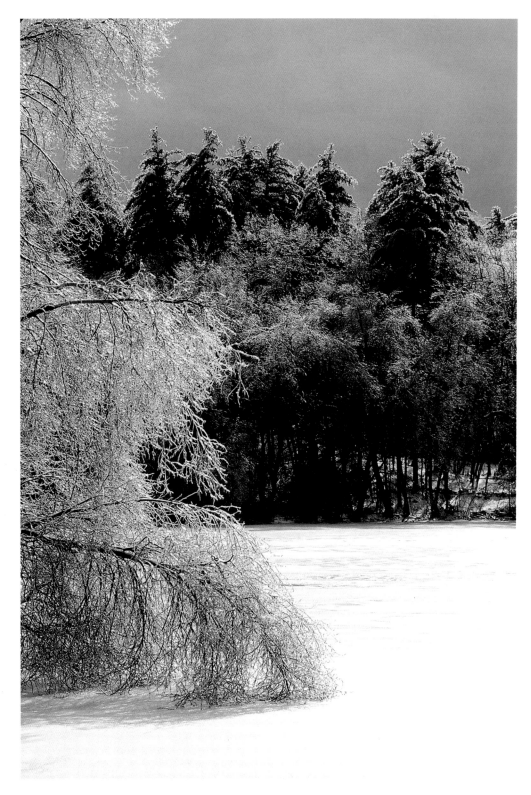

Hutchins Pond in Estabrook Woods

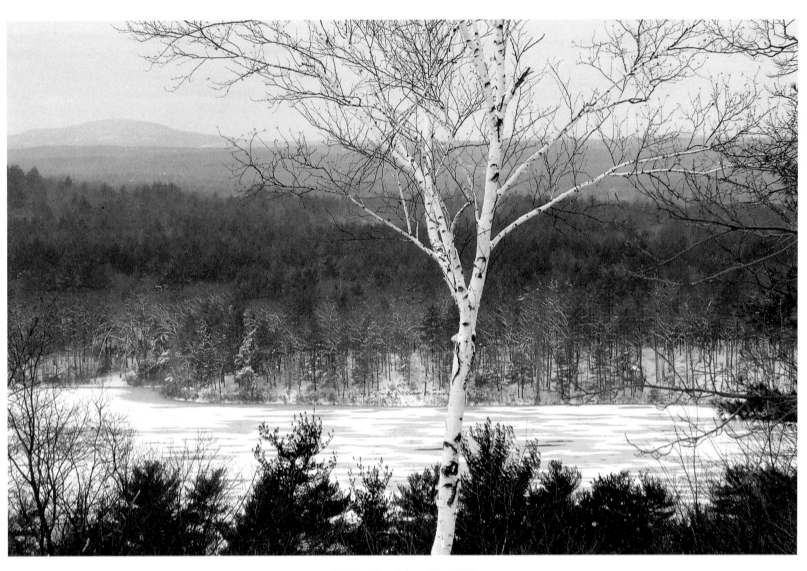

Walden Pond from Pine Hill

I wish so to live ever as to derive my satisfactions and inspirations from the commonest events, every-day phenomena, so that what my senses hourly perceive, my daily walks, the conversation of my neighbors, may inspire me, and I may dream of no heaven but that which lies about me.

—Henry David Thoreau

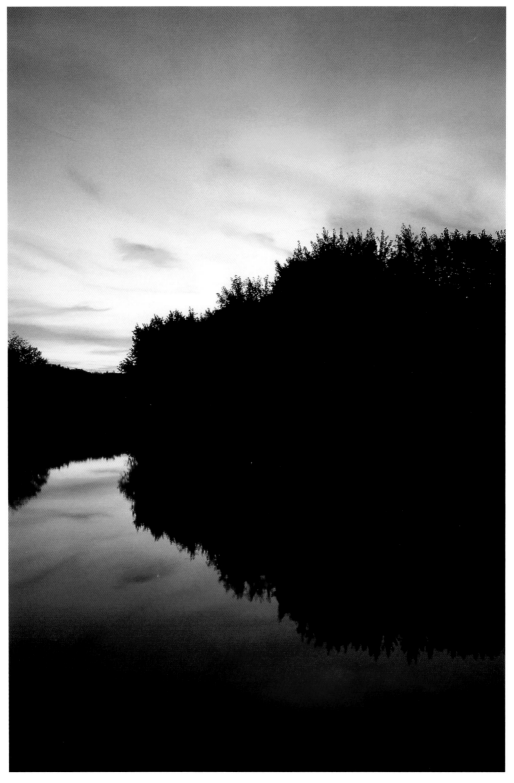

Concord River toward Egg Rock

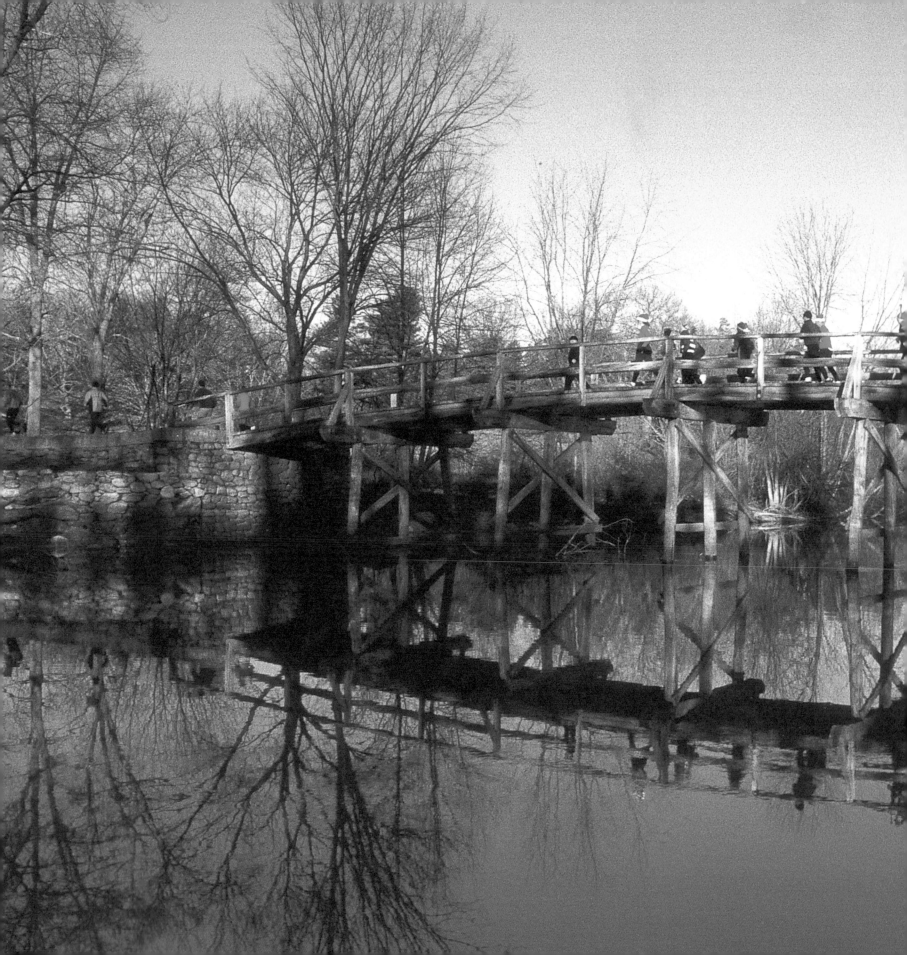